WELCOME TO
MAPLE LEAF
GARDENS

PHOTOGRAPHS AND MEMORIES
FROM CANADA'S MOST
FAMOUS ARENA

GRAIG ABEL & LANCE HORNBY

Foreword by Darryl Sittler

Copyright © Graig Abel and Lance Hornby, 2013

Published by ECW Press
2120 Queen Street East, Suite 200, Toronto, Ontario, Canada M4E 1E2
416-694-3348 / info@ecwpress.com

LIBRARY AND ARCHIVES CANADA CATALOGUING IN PUBLICATION

Abel, Graig, author, photographer
Welcome to Maple Leaf Gardens : photographs and memories of Canada's most famous arena / Graig Abel & Lance Hornby ; foreword by Darryl Sittler.

ISBN 978-1-77041-163-0 (PBK);
Also issued as: 978-1-77090-471-2 (PDF); 978-1-77090-472-9 (ePUB)

1. Maple Leaf Gardens (Toronto, Ont.)–History. 2. Maple Leaf Gardens (Toronto, Ont.)–History–Pictorial works. 3. Arenas–Ontario–Toronto–History. 4. Arenas–Ontario–Toronto–History–Pictorial works.
5. Hornby, Lance, author
I. Title.

GV418.M37A24 2013 796.06'8713541 C2013-902463-8

Editor for the press: Michael Holmes
Cover and text design: Tania Craan
All images © Graig Abel
Typesetting: Troy Cunningham
Printing: Friesens 5 4 3 2 1

We acknowledge the financial support of the Government of Canada through the Canada Book Fund for our publishing activities. The marketing of this book was made possible with the support of the Ontario Media Development Corporation.

Ontario
Ontario Media Development
Corporation

Canada

PRINTED AND BOUND IN CANADA

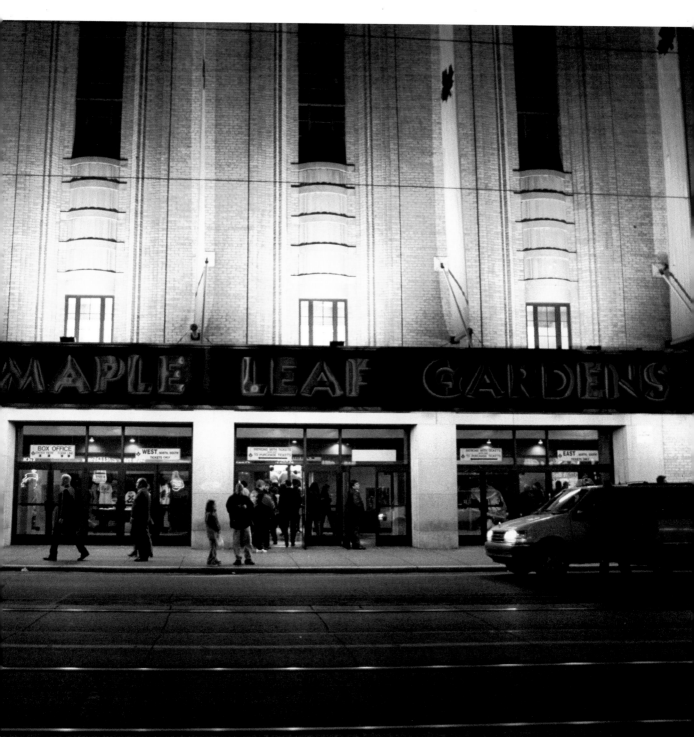

. .

This book is dedicated to my wife, Jane.

For 30 years, I worked two jobs, leaving the house at 5:30 a.m. for Chas Abel Photo. Many weeknights and weekends, I'd shoot my sports photography, not getting home until late. Jane spent many nights at home with our children, Dave and Katie, including nearly every Saturday night during the hockey season. When friends were going to parties on weekends, and I was shooting, Jane was at home. Never a complaint. She knew I loved my job.

For the last six years it has been Jane's time. Despite major cancer surgery, she has pursued her love of triathlon, and we have spent many weekends on the circuit during the summer. Her pinnacle to date has been the World Sprint Triathlon Championship in Auckland, New Zealand, where we went in October 2012. She placed seventh in her age group and was the top Canadian. We are off to the World Championships in London, England, in September 2013.

From surgery seven years ago, she has accomplished a great deal and, best of all, we are doing it together. I am so proud of her!
— Graig Abel

. .

To Katie
 The wait is always worth it and the best is yet to come.
 –Lance Hornby

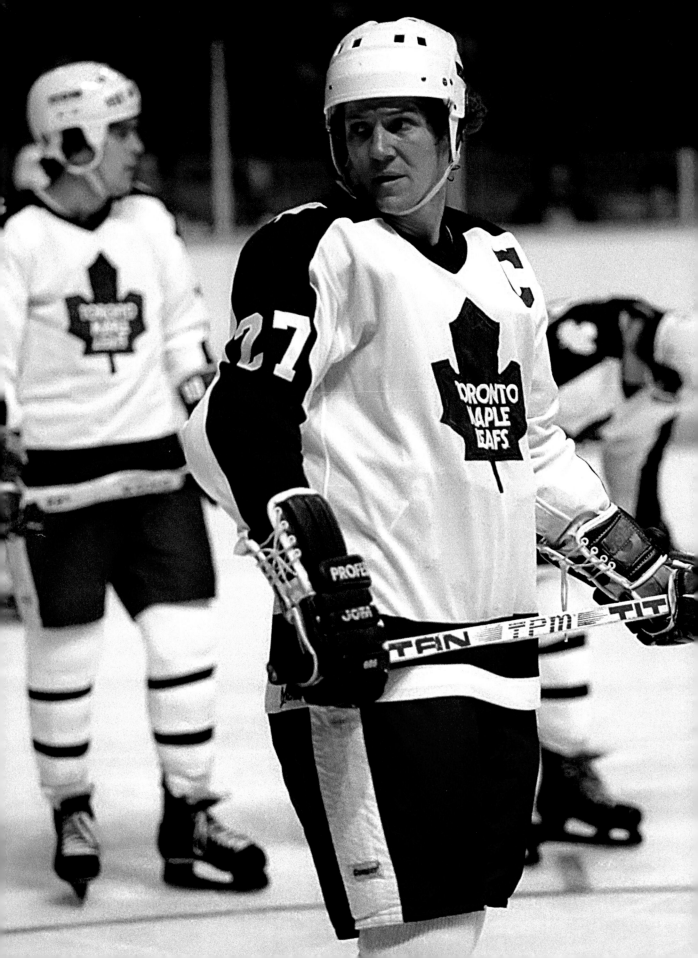

The very first time I walked into Maple Leaf Gardens was in 1967 and I couldn't stop looking up.

Our London Knights' bus had pulled into the side entrance for a Sunday game against the junior Marlies, in the same building where all my heroes played. I'd grown up in St. Jacobs, Ontario, watching the Leafs on *Hockey Night in Canada*, when the telecast for 8 p.m. games didn't start until almost the second period.

I thought I knew the place so well from TV, but it was much different when I was actually inside. The vastness to the roof—about 15 storeys at its highest point—and how far the rows of red, blue, green and grey seats extended was stunning. I had never been in a place that big. We had to dress in a small, cold room—it was later converted to the players' wives' lounge—but as hockey players we didn't care. We had made it to Maple Leaf Gardens.

I loved it there, and one Saturday night I joined a bunch of London teammates just to watch the Leafs and see the building with the stands full. We were in the standing room area behind the reds. It was incredible to see a game from that vantage point, with all the bright TV lights, the vivid colours of the sweaters and to be right among the fans. No one would have recognized me back then with my brush cut.

I was fortunate to be drafted by the Leafs eighth overall in 1970 and will always remember my first training camp at the Gardens. General manager Jim Gregory took me into the Leafs dressing room, which was an experience in itself, and showed me my stall. Hanging there was a No. 27 sweater. I felt so flattered, knowing right away the history of that number, worn by one of the most famous Leafs, Frank Mahovlich.

It took me a few games to score at the Gardens, but my first goal was on November 28, 1970, against Don "Smokey" MacLeod of the Red

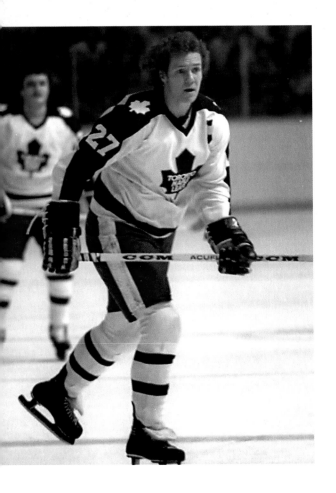

Wings. Earlier in that game was my first *Hockey Night in Canada* interview in the studio right across the hall from our dressing room. They brought you right in off the ice, sweating and panting. Someone tossed me a towel, just like I'd seen on TV as a boy. Here was my big moment: at the Gardens, on camera.

Host Ward Cornell welcomed me and joked that good things sometimes happened to rookies when they came on the show with him. Later in the game, I scored, with assists from Mike Walton and Jim McKenny. You can see me on the old highlight, going straight to the net afterward to collect the puck. I later went to the Hockey Hall of Fame and was able to get a copy of the game sheet from that night, which I framed along with the puck.

There was no other place you'd want to play than the Gardens. From the traditional opening ceremonies when the 48th Highlanders came out with their bagpipes, to the team family Christmas parties with Johnny Bower as Santa Claus, to the excitement of playoff time, you were thrilled to come through the doors.

The great thing about the Gardens was that we practised there a lot, too. I watched it change from the inside so many times through my 12 seasons with the Leafs. There were concerts, wrestling cards, roller derby and many other events. When they were adding more seats and private boxes, we'd be on the ice while workers were hammering and welding. It seemed that life around there never stopped moving.

But it was also the people, the characters, who made it such an interesting place. Smitty the dressing room helper, Cigar Freddie the maintenance man, the workers who sold popcorn, Bill Woan in the

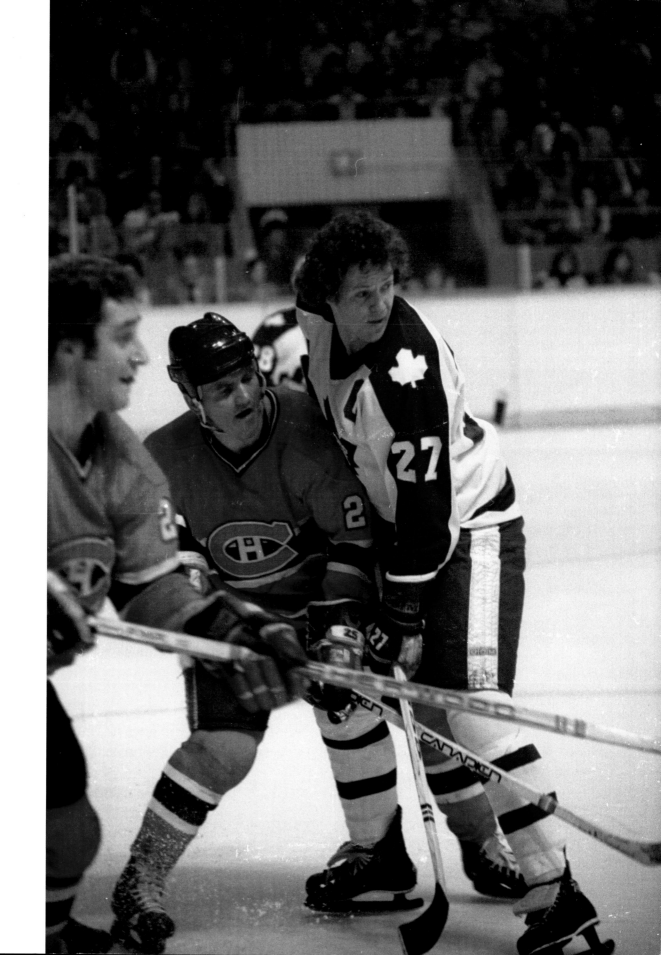

special ticket office, the guys in the parking lot, the ladies who ran the diner—and Graig Abel with his camera.

And, of course, there was the owner, Harold Ballard. When you were playing, you could sense him watching from his bunker, usually with King Clancy beside him. Everyone had this impression of him as a mean owner, but he was very good to me. In appreciation of my 10-point night against Boston in 1976, he presented my family and me with a beautiful antique silver tea service.

I also had the honour of meeting Conn Smythe, who built the Gardens

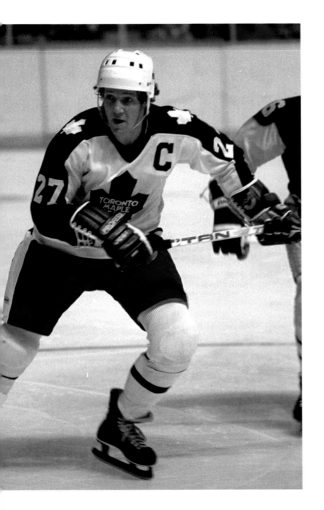

and had put the motto "Defeat Does Not Rest Lightly On Their Shoulders" in our dressing room.

Before the Gardens closed in 1999, I was able to get some of the seats from the reds, greens and golds and put them in my cottage, along with a few pictures of the place. I'm happy the exterior of the building has been preserved and part of it is still being used for hockey. I know many people from out of town still want to go there when they visit Toronto.

Enjoy this trip back to those memorable days at Church and Carlton.

Darryl Sittler
Toronto, November 2012

INTRODUCTION by Graig Abel

Whenever I'm at my cottage and we're raising a beer or two as the sun sets, someone asks me to tell a story about Maple Leaf Gardens.

People figure that as the official photographer of the Maple Leafs for 36 years, I must have great memories of their Carlton Street years.

And because so many people grew up with the Gardens, the tales flow easily. Everyone relates, everyone can identify with the characters and the setting—and usually have a personal experience to add.

It makes me think how fortunate I am to have spent almost three decades in the middle of the action, with a camera to record the story. What made it the best job in the world was that I was a Leafs fan, paid to be at every game with a front-row view. I also had free run of their home, the most famous entertainment arena in Canada. Talk about lucky.

Every aspiring Leaf has to start somewhere. For me, it was the Clarkson Paperweights team in Mississauga.

My parents signed me up as a five-year-old in the mid 1950s, with practices in the old Oakville Arena at 6 on Wednesdays. Thankfully that was p.m., not a.m., as it was a fair drive to get there. By about the second practice, I'd been sent to the equivalent of the minors on the Paperweights B team. I wasn't very good, but I sure loved getting on the ice and kept trying to get better. Eventually, I would make it as high as Junior B, as a left winger with the Streetsville Derbys, and later playing coach of my own senior team.

We had one of the first TV sets on the street—and the first colour set on which to watch the Leafs and *Hockey Night in Canada*. But I can't say my father, Chas, influenced me to play hockey. His passion was fishing and he went as far as Manitoba and the Arctic to do it. My brother, Doug, and I had some wonderful fishing trips with him in northern Ontario.

We'd take the train to remote camps, where they'd stop and let us off between stations with our gear and pick us up a few days later.

Two doors down from our house was where I learned to skate, thanks to a neighbour who made a massive outdoor rink. Little kids, such as myself, had the job of tramping down the snow before it was flooded. The best part was the neighbour worked for Hearn Pontiac, a famous west end Toronto dealership where some Leafs, such as the Hillman brothers, had jobs in the off-season. On Saturdays when the Leafs weren't playing, our neighbour hosted skating parties for the players and their families. In the summer, they were involved with charity baseball games near our street and All-Star NHLers would attend, such as Bobby and Dennis Hull and Frank Mahovlich. My friend and I got to be the bat boys.

I once had my picture taken with Bobby at the Byrnell Manor Hockey School in Fenelon Falls, which was run by the famous Frank and Bill Stukus. I was such a bad skater that they'd put me in goal—no mask, just a leather helmet. Sure enough, I was struck in the forehead by a puck. The *Star Weekly* happened to be there that day and took a picture of Bobby Hull applying snow to my wound.

When I was about seven, my uncle Andy took me to my first Leafs game. Like my dad, he wasn't a hockey fan, either; in fact, he loved watching wrestling. If I stayed at his house on a Friday, we had an afternoon nap so we could be wide awake to see the matches on TV that night.

Everyone dressed up for Leafs games back then. Uncle Andy, who looked just like Alfred Hitchcock, fit right in with his fancy wardrobe. Being so young, I had no real idea what the Gardens was like, just how excited I was to be going. I always watched Leafs games, right until bedtime, on Saturday nights. Now I was going to see them in "their" arena, the famous Gardens.

We had tickets in the greys, way up at the top of the building. I don't recall how much they cost, maybe a couple of bucks. I think they were playing the Rangers that night. I had never been in a building that huge before, but I remember I was a little disappointed the players were so far away, compared to on TV. Just into the third period I got bored and asked to leave. In those days, you could park right across Carlton Street, but they

jammed all the cars in so tightly there was no way out. We just sat in the car until the game was over and the people in front of us drove away.

But the whole experience did register deeply. From that point on, the Leafs were "my" team. Now I'd seen them play live and it was as if I had a personal ownership stake. I would not miss a game on TV, I knew all the players and checked their names and numbers at the start of the game when the rosters of both teams would scroll up the screen. My mom also signed me up for a *Hockey News* subscription, so I got all the info about what was happening with every team in the minors.

The Leafs were great back then, winning three straight Stanley Cups between 1962 and 1964 and another in '67. One of my favourite players early on was Eddie Litzenberger, because he had been a teacher at the Fenelon Falls hockey school. But I loved how Tim Horton played defence, the mean look Dave Keon had, Johnny Bower in goal and my all-time favourite, Mahovlich.

I didn't go to any of the Cup parades, though looking back at how long it's been since they had one, maybe I should have. As a kid, I didn't like it when the Leafs were knocked out of the playoffs, because it meant Danny Gallivan was calling the games on TV for Montreal. I thought he couldn't compare to Foster and Bill Hewitt.

When I was 14 years old, I made enough money to buy my own tickets, thanks to a really big snowstorm. I shovelled driveways and made $40 to put toward a future game. But when I was done my shovelling, I came home to find our neighbour from Hearn Pontiac had offered me two free tickets to the Leafs game that night.

I called my cousin to meet me under the clock in the front lobby of the Gardens. He lived on the TTC line, but I'd have to take the GO

commuter train, a journey of about 45 minutes. My mother drove me to the local station, but the heavy snow had cancelled the trains. The bus depot in Clarkson was shut, too, and with cellphones not yet invented, I had to take a cab all the way to the Gardens. So much for my $40, but I did meet my cousin and we had a great time at the game.

As the years went on, Dad starting getting better access to tickets. But the Leafs were not as good—in fact, they sucked. We had some last row north end reds on a semi-regular basis in the early 1970s and I would take my girlfriend (now my wife) Jane. Some nights we decided we didn't want to watch the Leafs play the equally bad California Golden Seals, so we just scalped them. We'd go to the Carlton Theatre next door and see a movie that would let out at the same time as the Leafs game. We'd listen for the score and a few details on the ride home, just in case we were asked what happened. No one ever suspected we sold the tickets!

We moved up to better reds in the mid 1970s, around the time the Toronto Toros of the World Hockey Association (WHA) rented the Gardens. Our subscriber friend had threatened to buy season tickets for the Toros if the Leafs didn't upgrade his seats and he kept his word, so now we watched games from the rails, just above Harold Ballard's bunker.

One night I was fortunate enough to get the royal treatment. With a year of Junior B eligibility remaining, I was approached to play for a team in Lorne Park, part of the Mississauga Hockey League. The coach was one of these types who tried to recruit the best players he could, and he would wine and dine players to get us on his team. He and his family were members of the Hot Stove Club, and he invited my wife and I down for a Leafs game. They treated us to dinner at the club, we sat in the golds and went back between periods for a beverage and popcorn.

After the game, we returned again for a steak sandwich. He won me over and I played six years for him, winning many championships in junior and senior divisions. But he'd brought me closer to the ice than I'd ever been. I decided that was the only way to a see a Leafs game.

You could say I had blue and white in my veins and silver halides in my DNA.

My grandfather was Charles (Chas) Abel, who came to Toronto from England in the 1890s. He wore many hats: tailor, bike courier, typesetter and then he opened one of the first phonograph stores at the corner of Bay and Queen. He later started selling Kodak cameras, but found there was no one nearby that developed film. So he started a photofinishing business in the basement of his record store.

That turned into him servicing drug store and retail accounts across Toronto, with huge businesses such as Woolco and Shoppers Drug Mart, plus hundreds of smaller outlets across Canada. Each day, he'd take film for developing to the lab, process it and deliver it back. The business was a total family affair. We'd drive to my grandfather's house in Mimico for Sunday night dinner, with all the Abel delivery cars lined up in his big circular driveway. After dessert, we'd sort boxes of film to be developed: black and white, colour negatives, slides and reprints.

It grew into Canada's largest photofinisher, run by my father Charles, Uncle Clarke and Aunt Margaret Smith. We also offered photographic supplies such as film, flash, cameras, batteries and frames, just about everything you could think of. Our lab ran 24 hours a day to keep up with the volume.

I was the one interested in how things ran: work flows, customer service, delivery and everything else that didn't involve sniffing chemicals. I began working with my dad, spending weeks in the summer helping out in any department. Once I got my driver's licence, I worked deliveries to the stores and took care of Priority Post boxes full of photofinishing at Pearson Airport.

Our flagship store was on Fleet Street, where Charles began printing the little photos the Leafs would staple onto mini wooden sticks as souvenirs. He was also a sponsor of the Toronto Maple Leafs baseball club, which played at the nearby Fleet Street Flats. My father joined him in the business after World War II. Just before the Gardiner Expressway was built, the store moved to Sherbourne and the Lakeshore.

Ironically, no one in our family was a great photographer. We were like the average person shootings birthdays and holidays. All my life there were cameras around the house, nothing too elaborate, essentially whatever was hot at the time. We could always pick up one and take a few shots. I'd messed around with sports photography and wasn't very good at first, but I worked at it. Thankfully, I had a lot of supplies to experiment with.

When I was about 24, one of my jobs was to look after the front counter at our Sherbourne store. Customers would bring in or pick up photofinishing orders on their way to work. I'd open the doors around 7 a.m. and be on duty until 10 when our receptionist would arrive.

Some customers would be in and out quickly, others would hang around laying out their prints on the counter to double-check what they'd shot. One of these customers, a guy named Norm, quickly became a favourite of mine because he was shooting Leafs games. Norm brought five or six rolls of film the morning after each game and when he picked them up next day, he'd lay a few out on the counter to order reprints of his best.

Norm's deal was putting together player albums with Leafs action shots

to be sold at the Gardens' concession stands. Naturally, I was looking at his shots, too, and I started chatting with him. When speaking with Norm, the fan in me took over and after a few visits, I gave him the same line people would give me a thousand times later: "If you ever need an assistant at the Gardens, let me know."

I never thought he'd say yes, but shortly after, he actually invited me to work a Leafs game with him, to see if I could help him.

Well, it was simply amazing with a capital A. I was going to shoot photos of the Leafs—my Leafs.

Finding equipment was the least of my problems. Our warehouse had stock cameras and lenses. They weren't top of the line, such as Nikon and Canon, but I picked a 35mm, a telephoto lens and a pocket full of film.

I met Norm at the north Church Street door. I didn't have a media pass, which made me nervous, but as we approached security he waved his own pass and said, "He's with me." And in I went—to a whole new world.

Norm positioned me in the northwest corner behind the front row rail seats. He told me not to move and that he'd come and get me near the end of the game. It was then he asked what my camera settings were. I kind of gave him a blank stare.

Settings? What the hell did he mean by settings? But he showed me what worked best for him. I was about to shoot my first Leafs game, with no real idea what I was doing, but I was determined to do the best job I could.

As the players skated out, I realized I was standing shoulder to shoulder with seasoned newspaper photographers. On one side was John Miola, a long time *Globe and Mail* sports guy. On the other was Frank Lennon from the *Toronto Star*, who shot the famous Paul Henderson goal in Moscow in '72. When the game started, I spent most of the time just watching the play, completely in awe of where I was. The speed of the action, how close I was

GRAIG ABEL
MAPLE LEAF GARDENS
PHOTOGRAPHER

to it and with my favourite players right there in front of me . . . what could be better? Eventually it dawned on me I'd better start shooting.

My playing experience had taught me to anticipate where the puck and the players were going, a big help deciding when to snap. I wanted the game to last all night, but the third period came so quickly and Norm reappeared to get me. I couldn't wait to see my results.

Norm came in the next morning to have the film developed. I was certain my stuff would be great and was already imagining my first cover shot for *Sports Illustrated*. We started looking at the prints, and I think that was the moment I realized what a zoom lens was for. I had followed the game well, but the players were these little tiny guys in distance. Overall, the shots weren't that good.

Thankfully, Norm was a patient man and said he'd give me another try. So back I went, and by the third or fourth game, I was getting the knack. Most of my images became nice and close, not entirely in focus, yet good enough for Norm to include in his albums.

As the season went on, I felt more comfortable in my surroundings and using the equipment. I was also doing lots of homework, checking out pictures in hockey magazines to learn exactly what's involved in taking a quality shot. I'd worked about a dozen games when Norm shocked me by announcing he was moving to California. My "in" with the Leafs was suddenly out.

I realized that if I didn't want to get the boot, I had to convince the Leafs I could do Norm's job. To my surprise I got an appointment the very next day to see Bill Cluff, the Gardens' business manager. I had a few

of my photos to show, though Norm still had the best ones in his possession. Before I could begin my pitch, Bill wanted to know all about Norm, how I knew him, how long I was working for him and where exactly he'd gone. I'm not sure what Norm was up to, but I don't think the Leafs were happy with him at the end.

I was getting grilled for the longest time and even Mr. Ballard stuck his head in the door to ask some questions. I kept explaining that all I wanted to do was be their photographer. Eventually, Bill told me, "Keep shooting and we'll figure out what to do with you."

Bill and I shook hands; he took me down the hall to meet Stan Obodiac of the public relations department.

I tried to sit down in Stan's office, but it was like an episode of *Hoarders*. There was stuff piled all over the place: media guides, newspapers and photographs. Stan asked how much I charged for an 8 x 10 black and white print. Thanks to the family business, I knew exactly what to say. I added a fair mark-up and gave him a price, about 75 cents each.

"No, no, no, I only pay 10 cents for an 8 x 10," Stan insisted.

I went back to Bill and told him things hadn't gone well. But Bill told me to deal with him from now on. There would be no firm financial arrangement. If they needed prints of players in action or autograph cards, they would pay for what they ordered. But if they ordered a lot of extra prints, which they did, I was going to be very happy.

I departed the Gardens that morning as the official Leafs photographer.

That's me in the middle of the back row, on the 1969–70 Streetsville Derbys. Believe it or not I was one of the tallest players on the team. Note the cheerleaders ("Gimme an S!") and our coach, Tom Barrett, who went on to the OHL.

INTRODUCTION by Lance Hornby

Around the turn of this century, Maple Leaf Gardens was the subject of a *Heritage Minute*, those TV vignettes that highlight famous Canadian people, achievements, monuments and societal shifts.

The Gardens could have been credited for its role in any of those categories. Beneath its soaring roof and between those massive walls, generations have come to see, to hear, to marvel, to celebrate and to shed tears of joy and sadness. Yet to relate its amazing tale and its place in the national conscience in just a 60-second clip is nigh on impossible. The story has such an unlikely beginning and an unwritten ending.

It was built against all odds, in the grip of the Great Depression when any new edifice, particularly a sports venue, was considered high risk. Yet team manager Conn Smythe was a gambling man; he knew he could no longer afford to play at the cramped 9,000-seat Mutual Street Arena, and he was faced with the prospect of selling his club to out-of-town interests.

Convinced that saving the team meant upgrading to the kind of landmark arena the New York Rangers had built smack in midtown Manhattan, Smythe set off in pursuit of his dream palace for hockey in the winter of 1930–31.

After carefully examining the pros and cons of potential sites around Toronto, Smythe became intrigued by a 350-foot lot that fronted Carlton Street at the corner of Church Street. It was underpriced at $350,000, intersected two streetcar lines and was close to the major pedestrian thoroughfare of Yonge Street.

The existing houses and shops that sat on the land were owned by Eaton's department store. But when the company's snooty brass heard the potential buyer wanted to put a sports arena on the lot, they had their druthers. Sports like hockey and boxing might lure the "wrong" crowd near Eaton's genteel Yonge and College location.

1978

TORONTO
MAPLE LEAFS

ACTION PICTORIAL

Raising money would prove to be the bigger issue. But Smythe, toughened by the First World War and a year as a POW in Germany, did not tread lightly where his $1.5 million project was concerned. He had assistant Frank Selke draw up a 10-cent prospectus to attract investors, illustrated with the first designs of the Gardens. He also catered to the wives of the rich and powerful when making his pitch about the grand plans, knowing they could provide the proper persuasion. At Smythe's urging, Foster Hewitt mentioned the prospectus on the radio and Hewitt's already powerful sway in that medium led to nearly 100,000 written responses, many with a dime tucked inside the envelope.

That show of support was needed to boost the confidence of Smythe's nervous co-investors. The blueprints were drawn up by Montreal architects Ross and Macdonald, a firm already well respected in Toronto for erecting Union Station and the Royal York Hotel. But Smythe still had a lot of finagling with the bank, and he made an eleventh-hour deal with union labourers to take part of their wages as future Gardens' shares.

It wasn't long before Maple Leaf Gardens (Smythe borrowed the fancy name from Madison Square Garden) began taking shape.

The Gardens employed 1,300 workers to build, from tearing down the lot to the actual start of construction on June 1, 1931. It required 760 tons of structural steel, 750,000 bricks, 77,500 bags of cement, 1,100 tons of gravel, 70 tons of sand, 950,000 feet of lumber, 230,000 haydite blocks and 540 hundred-pound bags of nails.

Low demand during the Depression gave Smythe a 30 percent discount on most of the materials. Despite the limited technology of the era, the Gardens was up in just five and a half months, a quarter of the time it took to build its eventual successor, the Air Canada Centre, in the late 1990s.

The last coats of paint were drying as 13,233 customers arrived November 12, 1931, for the opening Leafs game against Chicago. First arrivals marvelled at its 13,000,000 cubic feet of indoor space. Counting playoffs, the Gardens would host 2,533 total games, with the Leafs' final regular season record 1,215 wins, 768 losses and 346 ties.

When it closed in 1999, it was the last Original Six arena still standing and remains in use for hockey today as Ryerson University's Mattamy Athletic Centre.

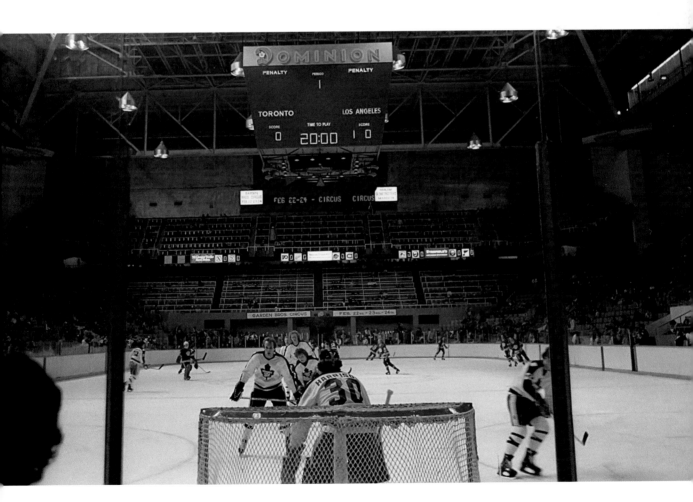

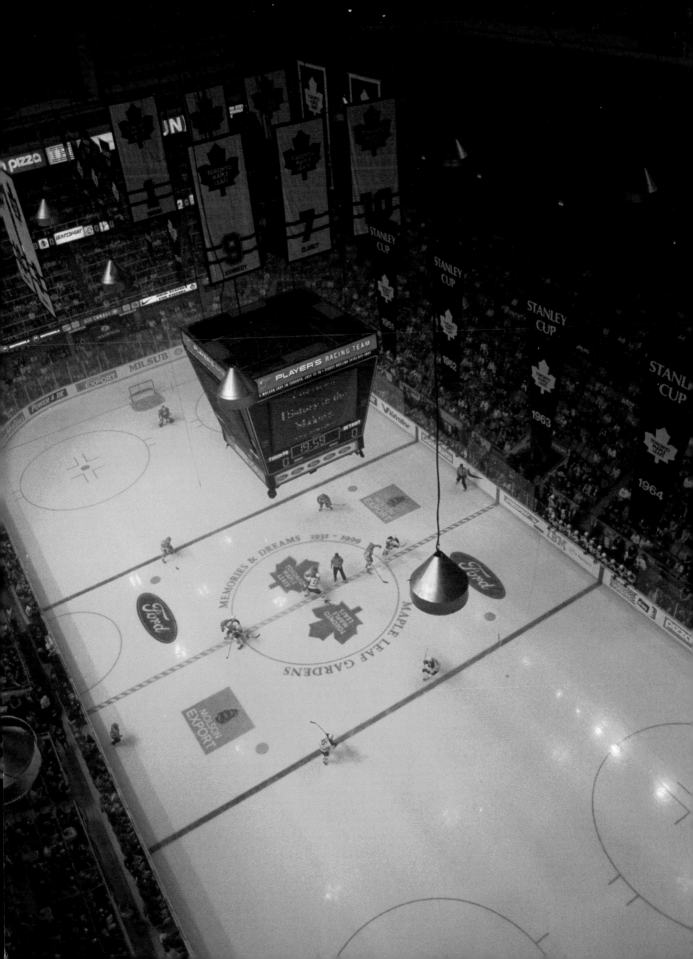

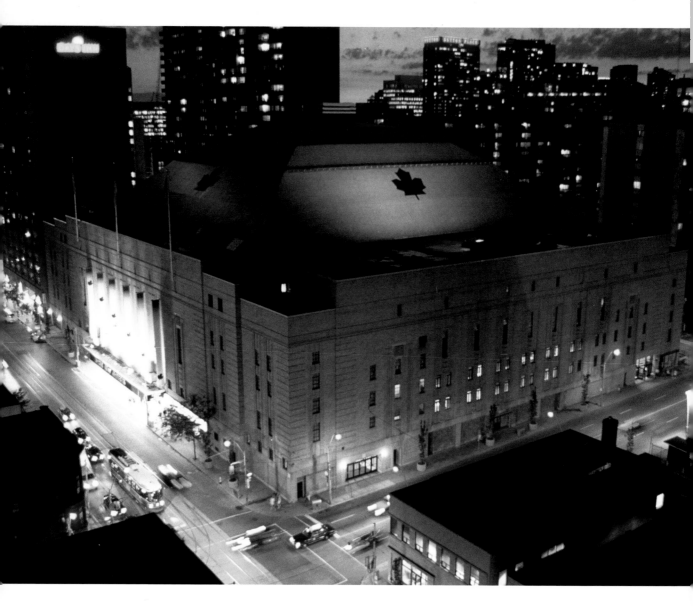

My most profitable photograph was of the Gardens at night, used in the program for the final game on February 13, 1999. I've sold several thousand copies of this image in all sorts of sizes through the years, 8 x 10, 16 x 20—and it's all that more valuable if someone like Doug Gilmour signs it.

Most NHL arenas produce wonderful art to show how nice their buildings are. But the Leafs had been using an old daytime exterior shot taken many years before I'd come along. Before taking my own picture, I did some research on photos taken around the league. I thought a nighttime

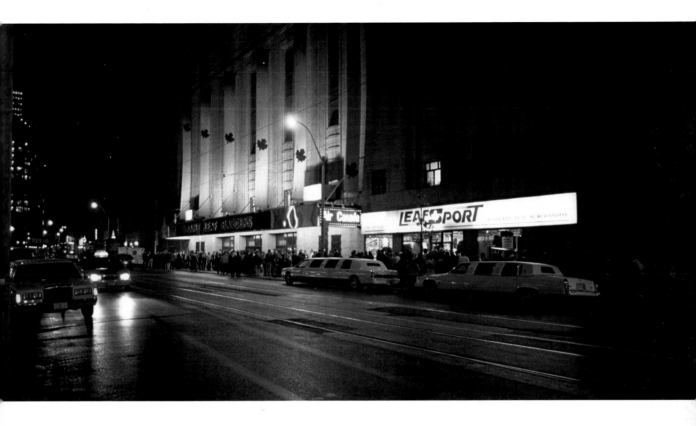

shot with the Leafs logo lit up on various spots on the roof would be ideal. Management really liked the idea, but then I had to find an elevated position from which to shoot.

There was a 17-floor apartment/office tower on the south side of Carlton, east of Church, with an unobstructed view. The problem—how to get on their roof?

I wandered in the lobby one morning, up to the front desk and talked to a very nice security guard. I asked if he was a Leafs fan (of course he was), explained who I was and what I wanted. For the price of some poster prints of his favourite players, my secret project was underway. I picked a late August date and asked the Leafs for interior lights on all floors, inside and out, to be kept on until 10 p.m., especially around the roof.

Around 7:30 p.m. on the appointed evening, a friend and I loaded up with assorted lenses and cameras as well as different films, slides and negatives. We got the thumbs-up as we passed my security friend and also managed to sneak in a few brown pops. I'm very afraid of heights and thought I might need some liquid courage if I had to sidle up to the edge of the roof.

Sure enough, there were no rails or anything to keep us from falling. We set up in the middle of the roof, my tripod with a timed exposure. The first shots looked fine, but not 100 percent perfect; I kept catching the corner of the building's roof in my frame. But I'd vowed not to get any closer to the edge.

We waited for the sun to go down, had some beer and started to enjoy a perfect summer night. I took some nice shots of the Toronto skyline while we waited, getting a little braver with each sip and moving my gear closer toward the foreboding ledge for the ideal shot.

The one I selected, as I said, has been used everywhere. Many news photogs tried to duplicate it later, especially during the 1998–99 season as the Gardens was closing. But we had the perfect night and the perfect lighting, and they could not figure out where I'd been positioned. I always know it's my image because you can see two young ladies on the corner of Church and Carlton hanging around, waiting for something.

I don't think it was a streetcar.

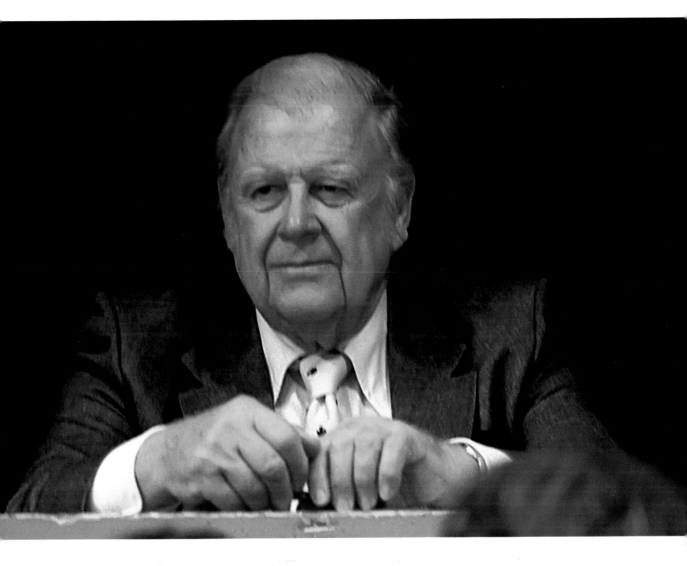

M ost pictures I took of Harold Ballard in his bunker were from the other end of the ice at a weird angle. He had this goofy rule that photographers couldn't work on the east side of the building.

Then one day I was called in by Bill Cluff. Harold had asked him about getting a picture I had taken of him and King Clancy. Mr. Ballard really liked the photo, but they were slightly obscured by a very tall fan sitting in front of them. He wanted the picture re-touched.

I told him no problem, even though I had no idea how to do it. I had heard of a guy on Carlton Street who did air brushing and photo restoration, gave him a call and showed up with a 20 x 24 inch poster for him to work with. We had a nice long chat about photography and my job with

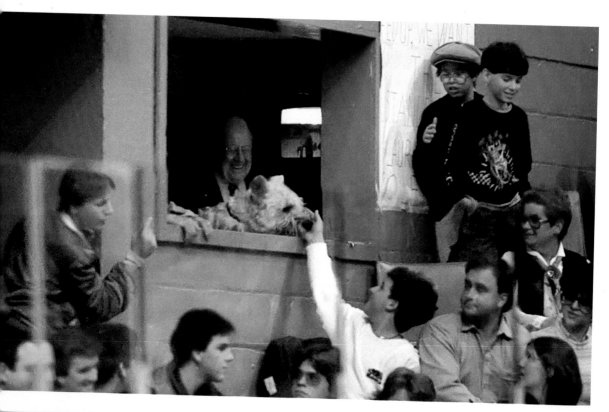

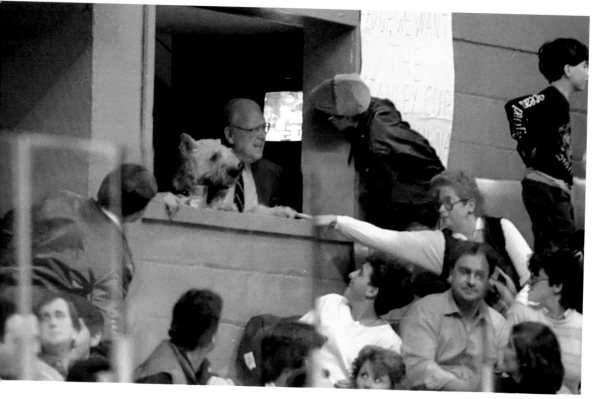

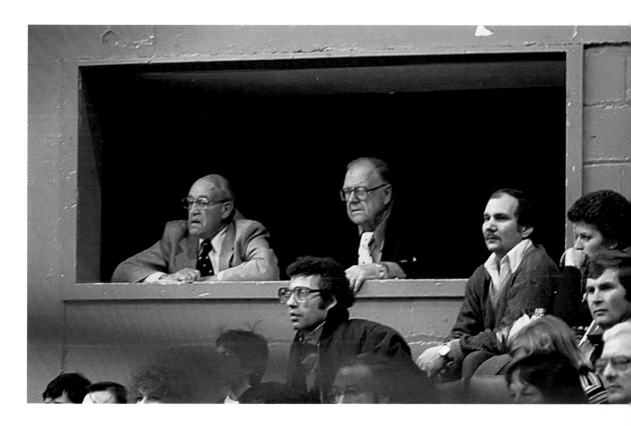

the Leafs and a few days later, he gave me a perfectly re-done picture. He even re-created Harold's hand on the ledge of the bunker. Mr. Ballard liked it so much that he hung it in the Hot Stove Club in a prime location.

Years later, I read a story about Ernst Zundel, who had been saying the Holocaust never happened and was jailed for publishing hate literature and was about to be deported to Germany. I recognized the name and realized he was the fellow I'd dealt with on Carlton Street. I guess if you can make things disappear in a photo you can try to make history disappear too!

Harold and I got along especially well after I gave him the picture. He even asked me to come over to the bunker and take his own portrait watching the game. It took several attempts to set up, because every night we scheduled, he'd wave me off, saying that he had the wrong tie on or the wrong jacket. I finally got the shot, and he was quite happy with it. I also like this one because it was the classic Harold face and he's wearing his Leafs tie.

When Mr. Ballard died, the Leafs asked me to print a poster of this photo, which was placed in front of the bunker. Most of the Toronto newspapers ran a photo of the bunker and my portrait the next day.

Most people think of Harold as a crusty old grump, but sometimes I'd see

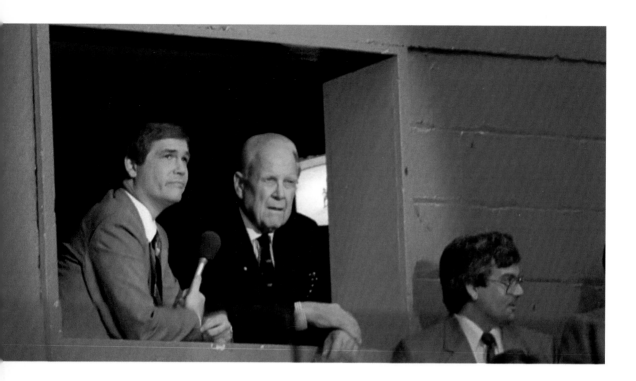

the other side of him. I was in the Hot Stove for lunch one day and he was sitting with six or seven kids, all enjoying themselves having lunch. I asked what was going on and was told Harold had taken these kids for a skate and brought them in for lunch. All of the kids were blind and he had arranged the whole special day for them. Most people never saw that part of Harold.

I happened to be looking in Ballard's bunker one night and snapped this one of Dave Hodge, one of the many times Harold allowed the *Hockey Night* people to interview him.

An assignment I often loathed was following up on one of Ballard's crazy comments, or, in later years, trying to decipher what would happen with the future of Gardens ownership amid his feuding family. It usually required a stakeout, either hanging around his bunker, the garage door on Wood Street or the Hot Stove—all places he frequented on game night. But he was virtually unreachable if he chose to be.

I was too young to be in his inner circle of favoured reporters, but he did give me some great interviews. On his 80th birthday, I jokingly asked him how such a curmudgeon had lived so long. Without missing a beat, he quipped, "Nice broads and anything adverse to what a human being should do." −L.H.

Here is King Clancy, Ballard's faithful sidekick, on what would be his last birthday celebration at the Gardens in 1986.

It was a surprise party for him in the Hot Stove. My job that day was to keep him busy taking his picture so the restaurant could prepare. I took him to the Leafs bench, up in the stands and to the special ticket office, pretending it was for the book on him, *Rare Jewel for a King*.

The title was a play on words because Conn Smythe won $10,000 on a long shot horse named Rare Jewel to get the money needed to purchase Clancy from the Ottawa Senators back in 1930. We finally ended up in the Hot Stove where I got a few more shots.

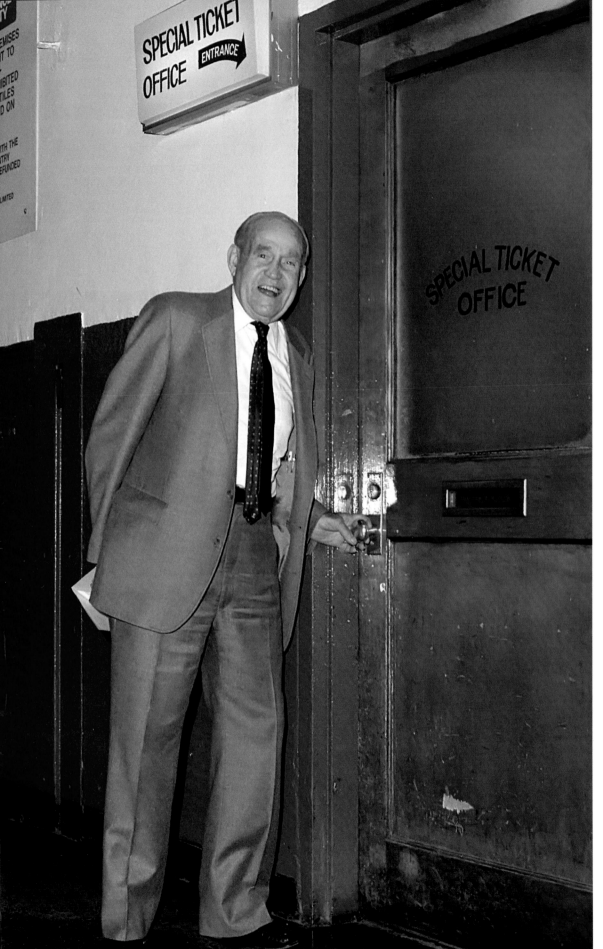

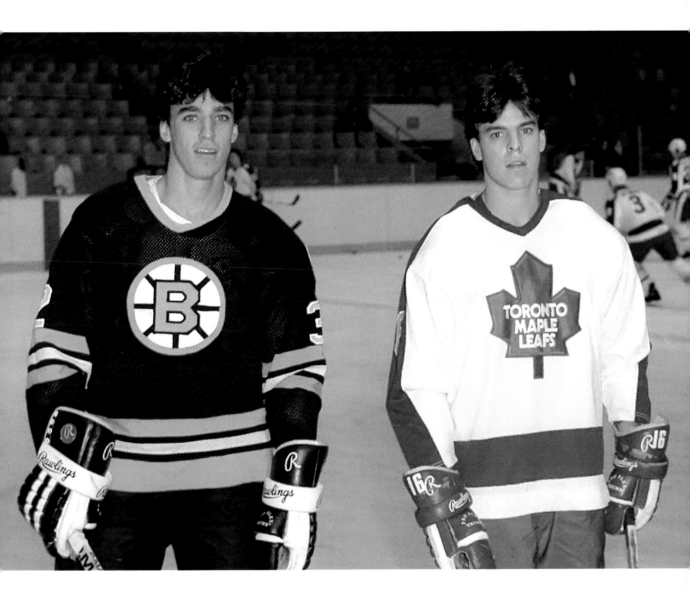

Hockey players are supposed to be bitter enemies on the ice. It doesn't matter if you are related.

But that animosity didn't extend to the Courtnall brothers. Russ was a Maple Leaf, and when brother Geoff came to town with the Bruins in 1984–85 (the first full season in the league for both), Russ asked if I could take a picture of them in warm-up. Players sometimes ask for such favours, and usually nothing ever comes back my way, but I didn't mind doing this one.

But if you tried to oblige and set this kind of picture up today, especially without the players wearing helmets, there would be hell to pay.

P re-game warm-ups were the perfect time to get some nice portraits done—with helmets off—or to catch players in a relaxed moment.
This is Al Secord and Wendel Clark fooling around in the late 1980s. Pictures like this were useful—and profitable—for another reason. I'm often approached by collectors who are purchasing game-used equipment and sticks online. They want verification that the player wore a certain number or type of sweater or used a particular stick. Someone who was about to buy a pair of Secord's gloves once asked for my help and this is the kind of shot that answers the question.

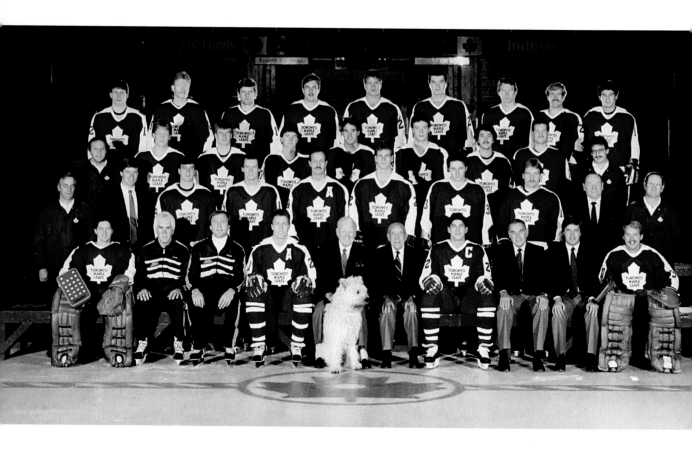

I was told the golden rule when taking the Leafs' official team picture was that if Harold didn't like it, you didn't come back.

My first few years at the Gardens, I didn't have a large format film camera, just 35mm, so I passed on doing the team photo. The printers wanted the largest possible slide or negative to reproduce it, but I had a good thing going as the game photographer and didn't want to screw it up.

I watched several people come in to try shooting it; I'd drop by to observe the set up and take a few shots with my 35mm. The next time the Leafs asked me to shoot the photo, they recommended I work with Dennis Miles. He had become a good friend of mine, after shooting Leafs games for the *Toronto Telegram* and *Toronto Sun*. He was well qualified for something like this, since he was also a corporate photographer for Molson Breweries, and taught the subject at Ryerson University.

I assisted Dennis setting up lights and carpets, testing the light balance and confirming that every player could be seen. Dennis took a few large Polaroids to make sure the exposure and lighting were perfect and then he did his large format stuff. When he was done, I stepped in with my 35mm

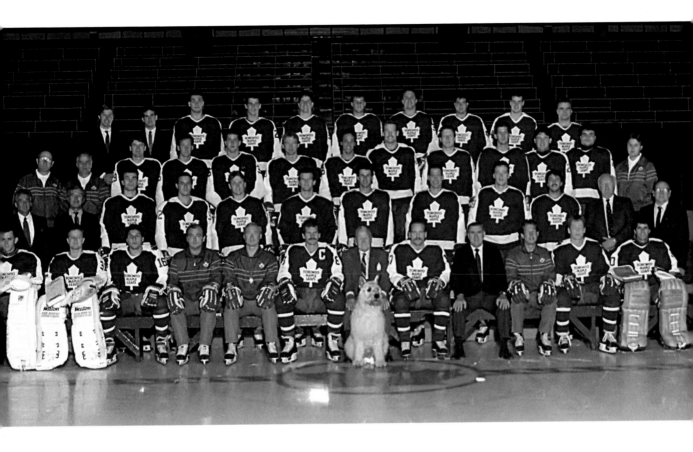

camera. My photos were fine for 8 x 10s and 11 x 14s, but Dennis's were sharper for the bigger publications. Dennis and I worked together this way on the photos right up until 2001, when we got our first digital cameras.

One year in the late 1980s, Mr. Ballard showed up for the team photo with his dog, TC Puck. TC was a big bouvier des Flandres, with a long and curly coat, who often ran around the Gardens. We got all set up and waited for Mr. Ballard and TC to arrive. He finally came out onto the ice and sat TC Puck down in front of him. The ice looked great, nice and fresh and without a speck of snow on it. The Leafs logo was perfect and there were no skate marks anywhere. Dennis started his shooting routine and the dog sat there patiently.

However, as any good Canadian knows, when you place a very warm hand on very cold ice, your fingers kind of stick. Now imagine a male dog on fresh ice. He was fine for a while and then he got a little sticky where you don't want to get sticky. Then he got very restless, began barking and wanted to run off. Mr. Ballard kept telling him to "Sit nice," while Yolanda, his partner, was yelling, "Hey Harold, the dog's balls are sticking to the ice!"

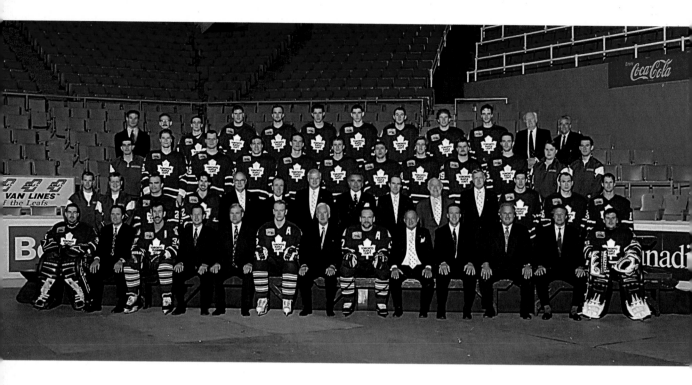

The players were all trying not to laugh and I'm looking through the viewfinder thinking this is the goofiest picture I've ever taken.

The photo shoot wrapped up pretty quick after that.

When Dennis and I finished shooting, he'd let the *Sun* and *Star* hook up to his lights for pictures for their newspapers. Dennis didn't receive a cent for allowing them to use his equipment, but that's how Dennis is.

One year, goalie Gord McRae showed up for the photo sporting a beard. Harold was angry when he saw the finished photo, wanting no part of a photo with a bearded player. Dennis was asked to replace McRae's head with someone else's without facial hair. Dennis quietly arranged to have this done and the re-touched photo was approved.

It's not that hard to take a quality picture of a major league team. But you have to be really prepared for shooting day and you needed someone, such as Bob Stellick in the Ballard days, to lay everything out properly for the players and the executives in the picture. It can turn into a real mess when no one knows where they're supposed to stand. And it seems there are more non-team people to include every year.

You fire off some test shots to see if the reflection is right. At the Gardens, they always did the ice perfectly, so you could even see the reflection of the goal pads.

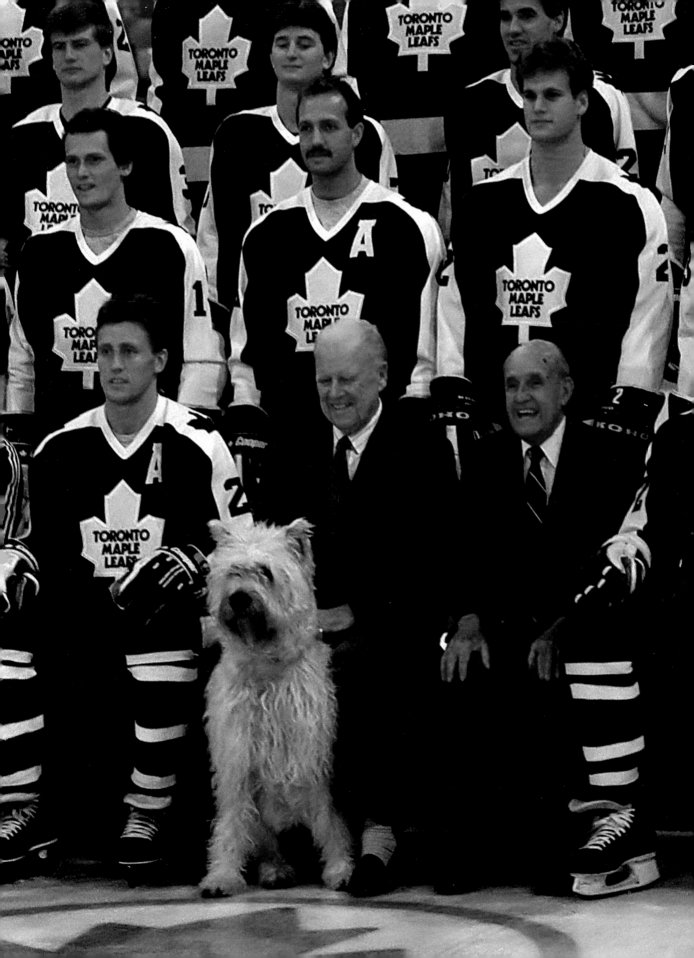

We can usually fix things like height differential, but some pictures are very challenging. One year, there were four Leafs goalies to fit in. And in the 1980s, the Leafs tended to use so many players you needed one team photo at the beginning in October, one in the middle of the season and one at the end.

One spring, they told us to get down there on short notice for an end-of-the-year pic. But they'd covered the ice that day. So instead of shooting at centre, we had to jam everyone on some benches in the corner. My son, Dave, worked some magic and restored the ice underneath them, complete with the reflection.

When I was a kid, every barbershop or auto repair garage in Toronto had a Leafs calendar, usually with a cigarette ad prominent. And there always seemed to be a Stanley Cup in the foreground. −L.H.

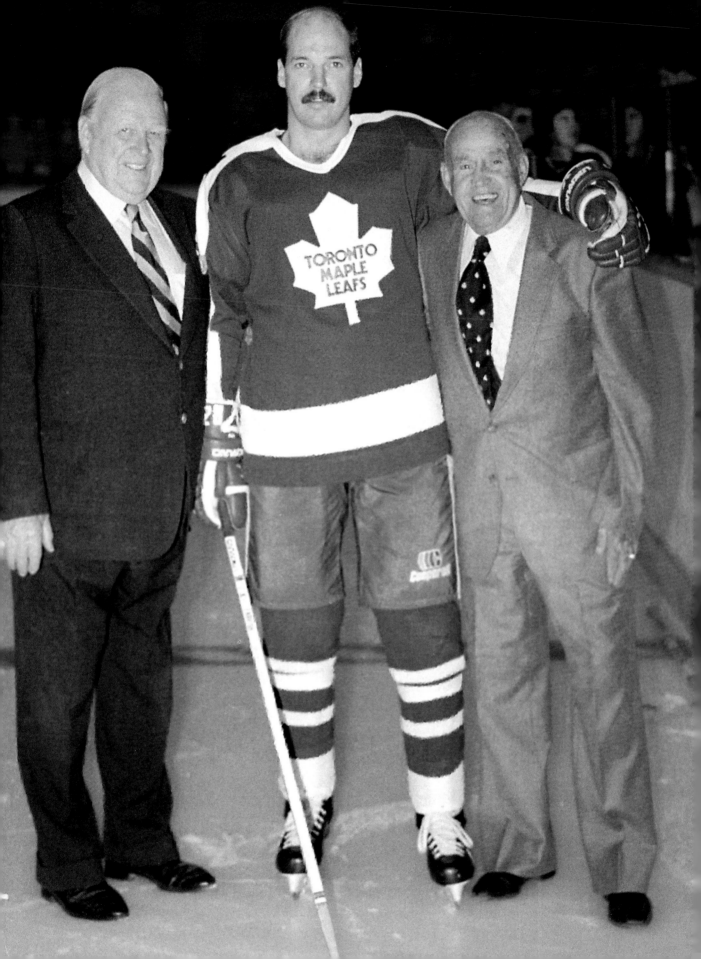

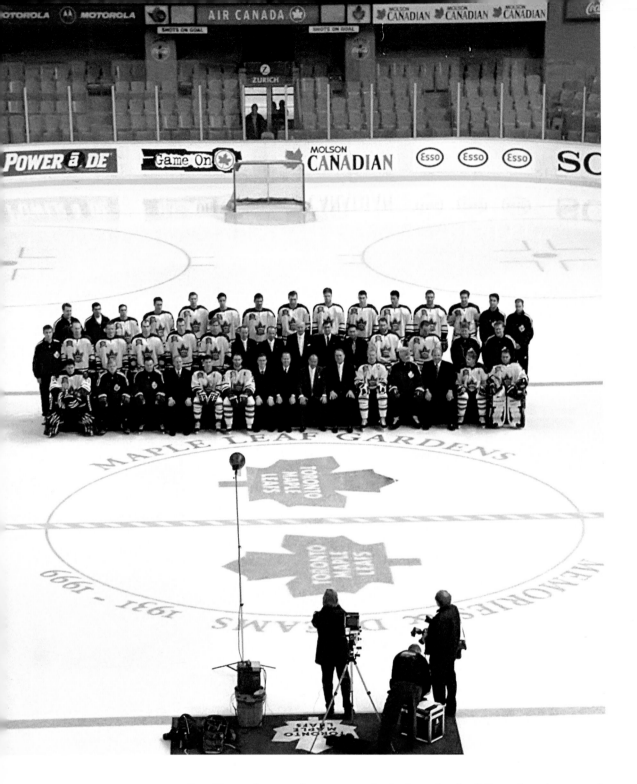

I n December 1998, two months before the building closed, we took the last of 66 team pictures in the Gardens. That's me behind the big camera in this photo taken by my son, Dave, high up in the north end.

W hen each season begins, the first things the players must go through are their physicals and having their individual headshot photos taken.

Whenever camp was held at the Gardens, I set up my backdrop and lights in the Hot Stove Club upstairs, while all of the medicals were done on the other two floors. It was a must to get your photo taken and you were not released for the afternoon until everything was completed.

The NHL demanded a set of slides and black and white prints of each player. I bought a special tripod that enabled me to mount two identical cameras, one with slide film and one with black and white.

The Leafs would sometimes invite as many as 80 players to camp in the mid 1980s, so it was always a busy afternoon. I have a bad habit of smoking and usually have a full pack sitting on one of the tables with my extra camera equipment. It was okay to smoke in a building in Toronto back then.

Everything was running smoothly this one particular year in the late 1980s, with players streaming in for pictures and then heading off to their medical stations for tests. There was a break in the action, so I had sat down to relax a bit when Al Iafrate arrived for his photo. Al's a real beaut and asked if he could have a cigarette. Just as he lit up, Chris Kotsopoulos came up the stairs and made the same request. After I took their shots, the three of us were sitting around chatting and smoking and having a great time. I should have brought a couple of packs that day because all the smokers on the team were grabbing one off me.

Al and Chris finished off their butts and down the stairs they went. Remember, this was supposed to be an NHL training camp. A couple of minutes later Al walked backed up and asked me sheepishly, "Uh, did I leave my urine sample here?"

I was sorry I couldn't help.

It seems that every year at opening of camp, one player gives me a hard time or makes me wait forever. When Ed Olczyk came to town in 1987, he arrived for his first headshot day. Ed had on a yellow T-shirt, which I asked him to take off for the picture. The NHL rules were no coloured shirts under your team sweater unless they were team colours.

Ed refused, saying it was his lucky shirt. We had a discussion that was going nowhere fast. But when Gord Stellick, the Leafs GM at the time, finally arrived, he took over the conversation. It took Gord a while, but he finally convinced Mr. Olczyk to remove his yellow shirt.

Then there was a rookie Toronto picked in 1996 named Brandon Sugden. Rookies never do anything on opening day on their own and usually travel with one or two other kids. This young player and his buddies came up for their shots, and he was definitely the jokester of the bunch.

He sat down and gave me a big gap-toothed smile. I politely suggested he might want to put his teeth in for the photo, but he just laughed and said his mom would love it. The other guys thought it was pretty funny, too, so I just snapped the photo with his big toothless grin. I don't believe I ever saw him again.

Another young man came up and I had no idea who he was. He was supposed to have a training camp number, which I would later match to a name. I did know that the lower your training camp number, the better chance you had of making the team.

The rookie took one look at the numerical roster and laughed.

"The Leafs have real plans for me this year," he joked. "Last year I was 74 and this year I am up to 72."

I don't think I saw him again, either.

Here's one of Chris Kotsopoulos, one of my favourite Leafs. Not only was Chris a great quote, but he'd talk while lighting his cigarette with the blowtorch players used to curve their sticks. He's now a colour analyst for Quinnipiac University's hockey team in the States. –L.H.

Al Iafrate was one in a million.

One day I invited my brother-in-law to drive down to the Gardens to meet me for lunch. He excused himself to go and pay his parking and came back into the Hot Stove all confused because the parking guy wouldn't help him. I went out to investigate and found Iafrate sitting in the one-person hut the parking attendant was supposed to use, slowly eating a Big Mac.

The Leafs dressing room wasn't my favourite place at the Gardens, because it was so small. There was hardly any room for the players or me to move. Brian Papineau, who was and still is their equipment man after 2,000 games, had to be creative, storing sticks underneath staircases. I didn't really want to be in there with a bunch of stinky players and their equipment. I often thought about how I'd had a bigger, nicer place to dress when I played for the Streetsville Derbys.

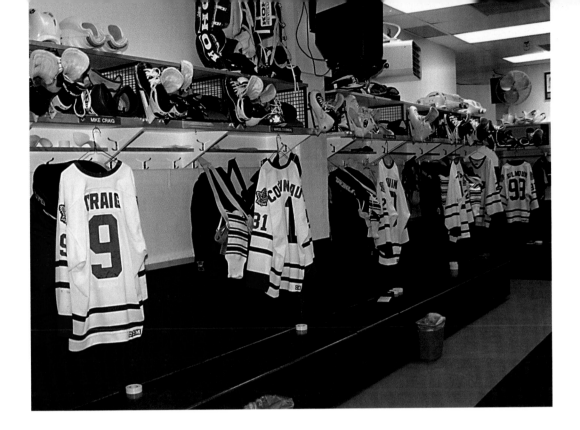

But you could understand what it meant to a fan to see it, if they could. You walk in that door and imagine Mahovlich once dressed there, you wonder where Wendel Clark used to sit and you could picture Dougie Gilmour at his stall, giving a speech.

When they upgraded the dressing room in the late 1980s, as well as the training facilities and medical room, Bob Stellick asked me for some new pictures to mark the occasion. Most of the new facility was built in a renovated area under the Hot Stove Club, as there was little or no room on the ground floor for expansion.

The Leafs were out of town the day I went to shoot, but there were some injured players doing their workouts. Security was never a strong point around the Gardens, but I was escorted to the room in case there were any players around. We went down the long hall to the new training room and when I was finished getting shots, I went back up to work in the main room. Out of the shower area came big forward John Kordic with only a towel around him. He was surprised to see me in there, with a camera, and vice versa.

I explained what I was doing and went on shooting, while John continued to wander around. There was also a new entrance to the room that had just been built, which led to the main hallway. Since there wasn't

supposed to be anyone around that day, all of the doors were open. But Kordic, who was not shy at all, started yelling at some ladies who had popped into the lobby just to take a peek at the famous Gardens.

"What are you looking at?" Kordic shouted, enjoying their embarrassed looks. "Here, I'll give you something to look at."

And he started toward the doorway in his towel. But it was quickly slammed shut by my escort and our photo shoot came to an end.

The tunnel went under the east hallway and came up through the Hot Stove. Some nights, that's how the players would make a quick escape.

I knew the Leafs rooms had seen a lot of players come and go (almost 900 by the start of the 2013-14 season), but it took a meeting with 1930s captain Red Horner to put that in perspective. At age 87, Horner came up from Florida to his old hockey home and graciously answered questions about playing in the Depression era and explained how he used to sell coal to the Gardens after retirement until the dastardly oil and gas companies arrived.

How many great stories originated in that room, whether from the Leafs or special guests like Bob Hope?

But it seemed I spent the best years of my life outside that door, waiting for players. They were either reluctant to talk after a loss, getting treatment, having a team meeting or stalling in some way. Some coaches, such as Pat Burns, John Brophy and Mike Murphy, knew the press had its place, because it meant accountability for players. Others, such as Pat Quinn, were irked by the mere presence of ink-stained wretches on their turf.

But the biggest barrier of all was often Harold Ballard, who banned female reporters from the locker room in the 1980s and then under the guise of "equal access," was able to keep all media out for a few years. One night, in a move that Canadian Press called "guerilla warfare," Professional Hockey Writers Association president Scott Morrison organized a storming of the barricades. After waiting 10 minutes, the post-game league mandate observed in every other rink, about 20 media pushed open the doors, past security and began conducting interviews.

"Is it Christmas?" one surprised player said.

Ballard got wind of the invasion and had his attendant push his wheelchair at top speed to the dressing room, where he whacked a *Globe and Mail* photographer with his cane. But soon after the league finally pressured him to open the chambers to all reporters. —L.H.

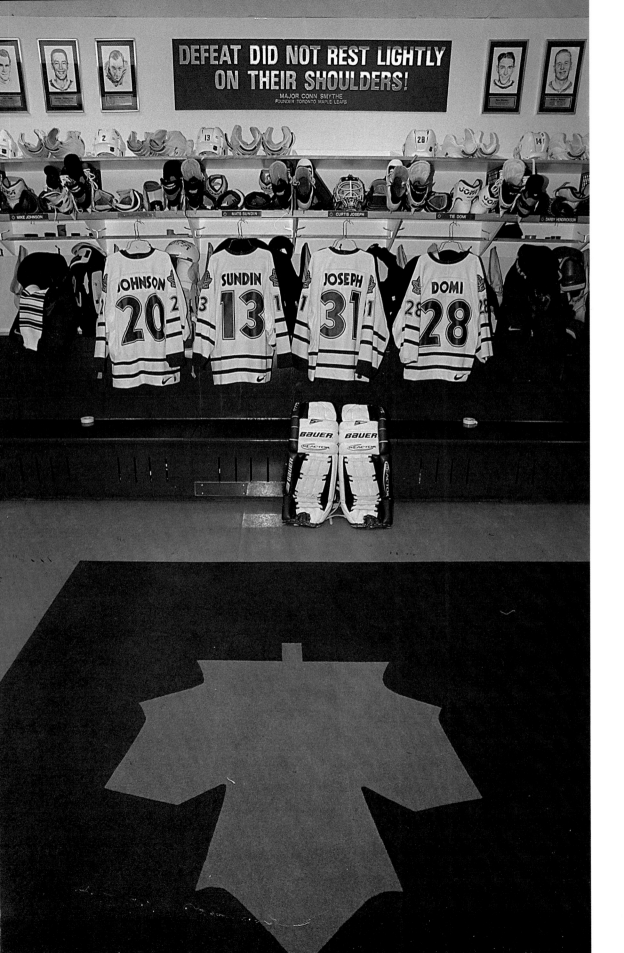

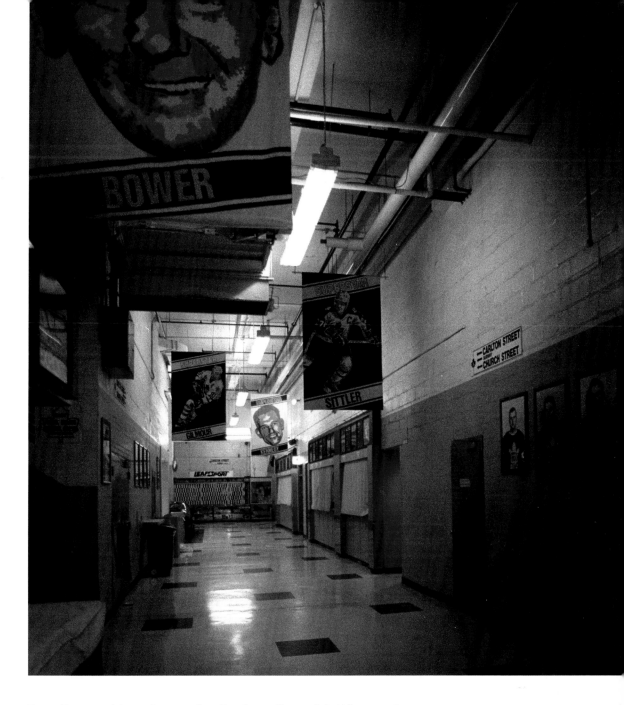

You could get lost in the Gardens if you didn't know where you were going. Snaking corridors, back halls that led to rooms seldom used—I worked there for 20 years and there were still places I had not seen.

The Gardens had a lot of neat features people didn't see. A huge old-fashioned vault in the special ticket office. A bowling alley that was rarely used after the 1930s. Unusual staircases, both steep and spiral. One of my

favourite places was a back maintenance room where I could light up after the building became a strict no-smoking facility.

But there was one game in the mid 1980s when Mike Keenan was the visiting coach and was holding a meeting of his assistants. He got all pissed off when he found out what was going on in the "smoke room." That was the end of smoke break, though Pat Quinn somehow could enjoy his cigars in the building and not get in trouble.

There was the press room where the media and scouts ate these little egg sandwiches, made by a wonderful woman named June. You washed them down with a Coke or some coffee, but to get there meant a trip to the corner of the top floor, higher than the last escalator took you. Not a place to visit if you weren't in tip-top shape.

But the Gardens was always nice and clean and well maintained. It always received a fresh coat of paint a week before the season started.

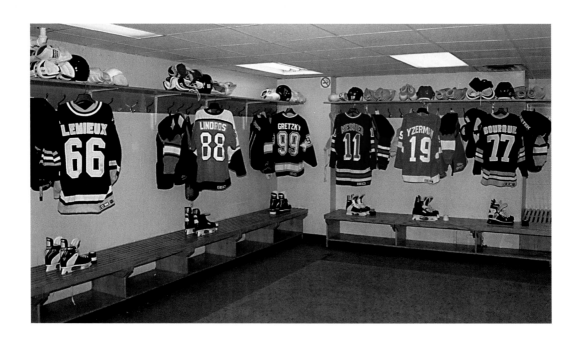

The visitors room had to be the most out-of-the way place in the Gardens, buried in the northwest corner, like a dungeon. Even though the main Leafs room was kind of cramped for the home team, this place was twice as bad for the visitors, especially their trainers, who had to find space to sharpen skates and do their other tasks.

I think I went in that room exactly twice, to take this picture and once after an Oilers' visit. Someone had asked me for a shot of Gretzky, Oilers owner Peter Pocklington and former prime minister John Turner.

To get to that room, the visiting players had to go past the Zamboni entrance and take a long walk from there. If they were mad at a loss or had been kicked out of the game, they sometimes took it out on the poor old ice machine. Ulf Samuelsson (then with Hartford) had a fit one night and he chopped a hole in the Zamboni's grill. The Leafs sent him a bill for repairs.

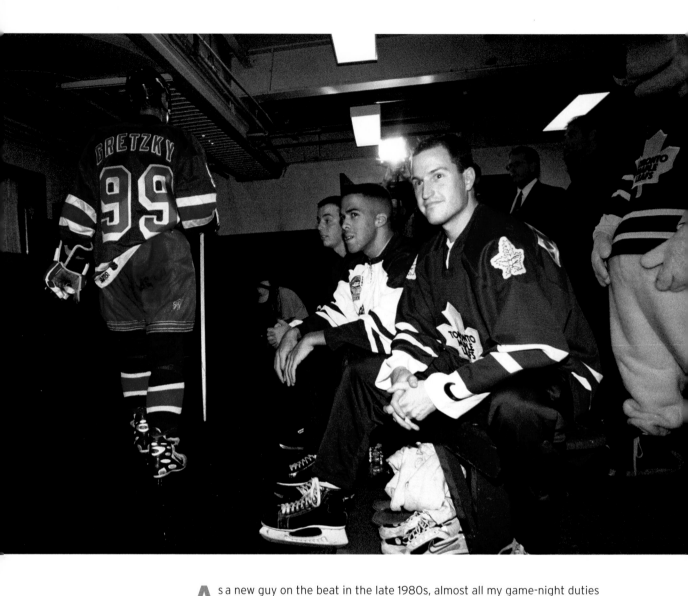

As a new guy on the beat in the late 1980s, almost all my game-night duties were centred on the visitors room for the sidebar story.

But I grew to dread the frequent visits by the Norris Division rival St. Louis Blues and their volcanic coach, Brian Sutter. They had a habit of losing close games at the Gardens and with the Toronto media covering the home side and only one St. Louis beat guy on the trip, it was often just Sutter and me for a very uncomfortable 5 or 10 minutes. Sutter would stomp around, re-tracing his steps, eyes glowering, looking like a caged tiger from the Ringling Bros. Circus that often set up in that corner of the building.

After getting up the courage to ask a question, I'd brace for a double barrel blast from Sutter, who'd get right in my face, ranting about his team's mistakes

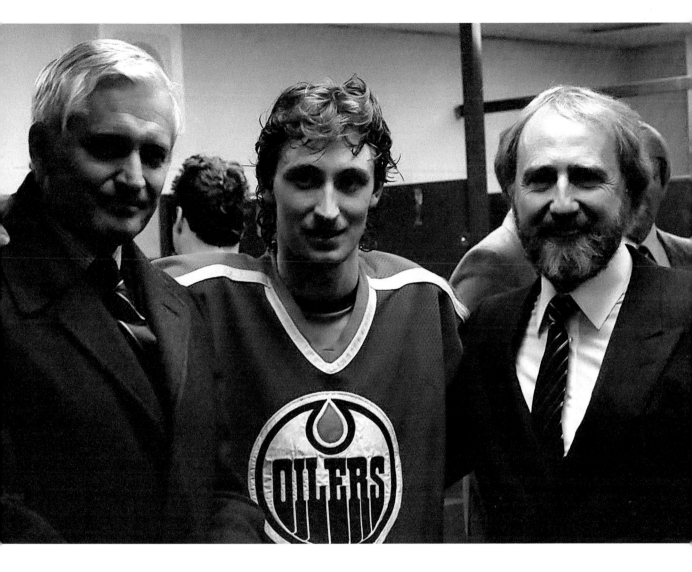

or something nefarious the Leafs or the officials had done. Then he'd turn away and repeat his ritual, complete with the stomp and the snarl, awaiting my next question.

Graig's right about the lack of space in the room. With players, equipment men, media and hangers-on, it could get tight in there, especially when hockey royalty, such as Gretzky, was in town. When Gretzky came back with the Kings for the first time in 1988, my late and loud colleague Jim Hunt broke up the huge scrum by complaining the Gretzky tabletop hockey game he bought for his grandson had broken. No. 99 immediately stopped the proceedings and promised a refund.

The other problem the crowded room created was that mumblers or

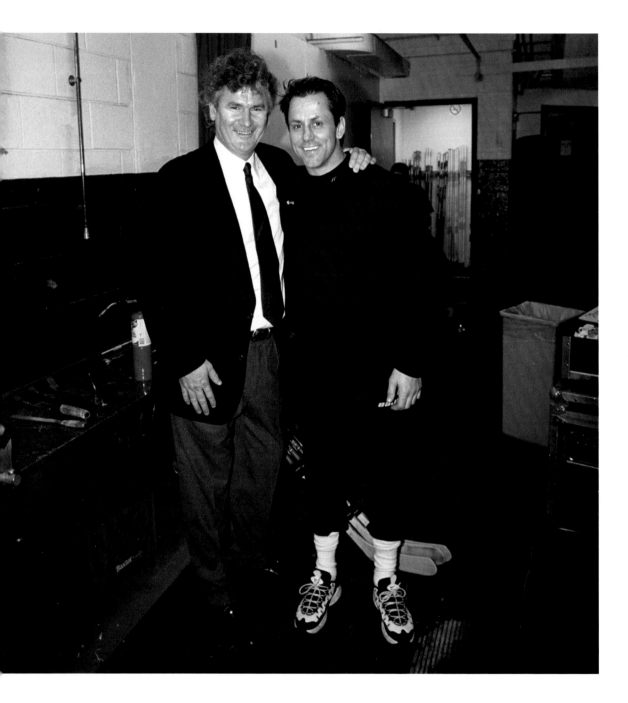

soft-spoken players such as Steve Yzerman were just about impossible to hear unless you were right beside them. That meant standing on every inch of available space, including the adjoining stalls, hanging precariously with one arm and thrusting your tape recorder with the other, hoping you could make out two or three words later. −L.H.

f someone deserved to call himself the Voice of the Gardens, it was Paul Morris.

His official job title was listed as head of the Gardens' sound department, but he was the public address announcer for the Leafs from 1961 right up to when the building closed.

He was a really nice guy, but what amazed me is that they put him way up in the northwest corner, with just a little window to look out and see the ice. He had a little radio that they used to relay him the goals, assists and penalties to announce.

The Morris family had ties to the earliest days of the Gardens when Paul's father, Doug, was the first building superintendent. Doug was credited with such hockey innovations as the four-sided clock, goal lights and penalty time-keeping. Paul helped build the Dominion clock, the first digital model in the league with an angled screen for people in the lower seats. He and his father were also big fans of the opera, which led to the Metropolitan Opera House company visiting from New York for many successful runs.

On October 14, 1961, regular Gardens PA man Red Barber didn't show up for work and Morris was asked to fill in. For the next 38 years, Morris didn't miss a Leafs home game, working 1,561 in all. –L.H.

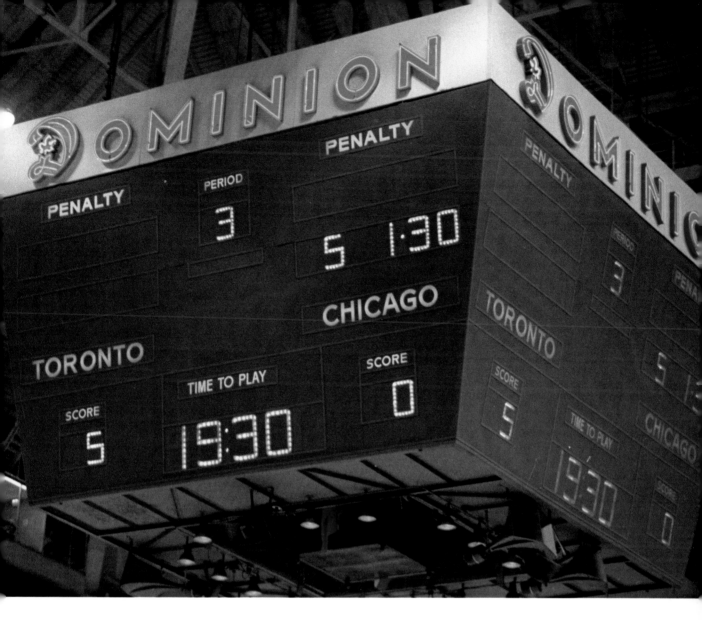

When I started, the green Dominion clock was still in use.

It was the hugest thing you ever saw, especially when lowered to ice level and with people walking around it and fiddling inside it.

There was a capsule that dropped down from the main clock during the national anthems, with a blow fan that made the Canadian and U.S. flags flutter.

A newer clock arrived in 1983. It was state of the art and had graphics for the first time. What I remember are the workers having to lower it all the time to change the 40,000 coloured light bulbs.

In those days, the Leafs would put up announcements for birthdays

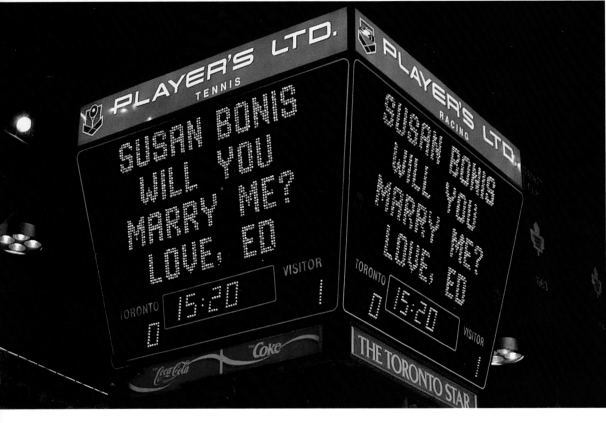

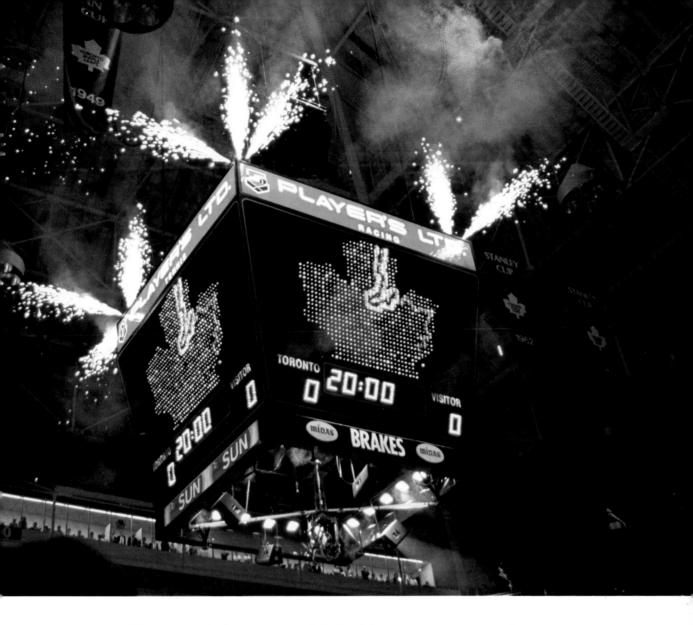

or wedding proposals. I even arranged for birthday greetings a couple of times for young relatives, knowing how much it would mean for a kid to see his name in lights in front of 16,000 people. I always thought it was a nice touch to have a proposal or something like that. Sadly, they don't do it anymore at the ACC.

I was always tipped off to these announcements at the Gardens and made sure to get a picture of the board, which would be worth $10 to $15 to me as a reprint. It would almost pay my parking on game night.

Ah, the good old days.

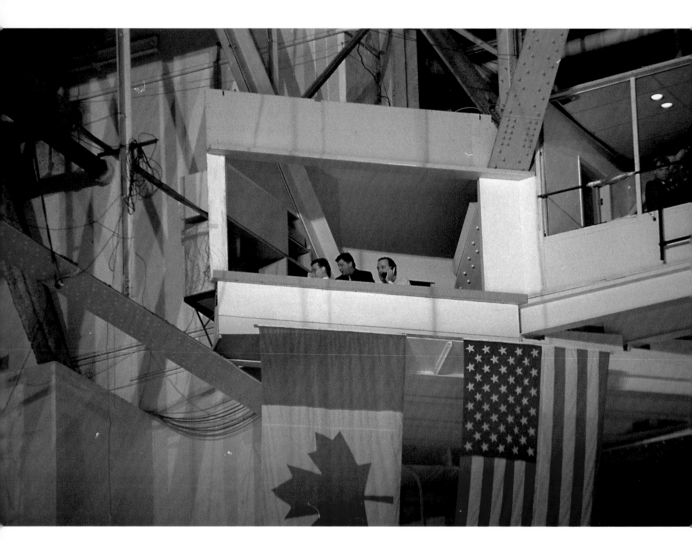

The famous Gardens Gondola was gone by the time I arrived. The catwalk out to that overhang was reputed to be one of the scariest walks you could ever take. Many who were afraid of heights refused to go. But after Ballard had the Gondola scrapped, there were still some precariously high places from which you could watch the action on ice or on stage—if you dared.

In the early days, I had to go up and down to the rafters a couple of times a day to set up lights and timers. I was walking on 2 x 8s with virtually no railing. I hated it up there and didn't want to look over the edge. No one was really supposed to be up that high, but by the time I started in '77, lots of beer bottles and junk were stashed there, so you knew the workers must have hidden out now and then.

When I got to the end of the walkway, I had to crouch to clamp all my lights in, which were mounted on beams hanging over the private boxes. To turn the lights on, I had to carefully walk out on a beam and switch them on—a little tricky, with no room for error.

One night, a regular newspaper photographer could not make it to the game and they sent in a replacement. But the new guy didn't get the full safety lecture, because he took a step onto the drop ceiling of a private box and crashed right through, landing inside amid a pile of tiles, dust and debris.

Instead of informing someone what happened, he got up, dusted himself and exited the box through the door and continued with his night's work. The angry box owners arrived at the game to see their luxury suite filled with rubble.

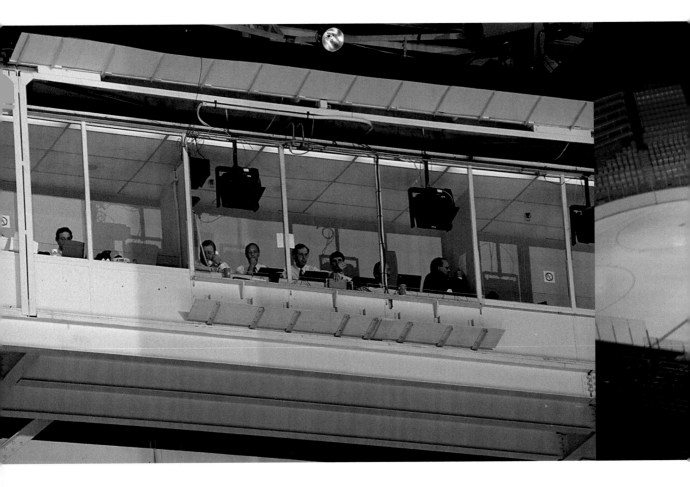

Sports Illustrated came up to that spot two or three times a year to shoot some games. They had monster strobes and left miles of cable behind, which I had to step around. In general, I found that shooting position so high up that you couldn't even read numbers clearly. All you ended up with were the tops of heads and helmets.

This picture shows one of my strobes positioned above the press box where the off-ice officials are. And I think that's a young Lance Hornby on the far left.

It's said that when Conn Smythe asked Foster Hewitt where he wanted the Gondola positioned in the new Gardens, Hewitt went to an Eaton's department store and began climbing the stairs and looking down at shoppers. When he could no longer make out their faces clearly, Hewitt stopped. It was the 54-foot mark—and that's where the Gondola was erected. —L.H.

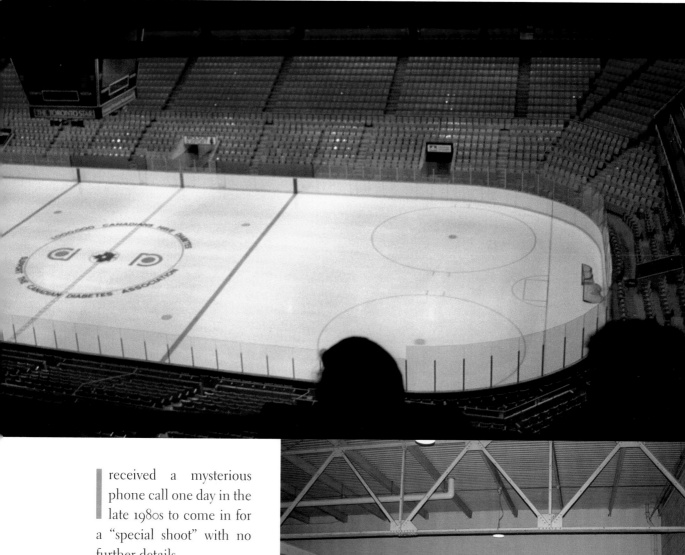

I received a mysterious phone call one day in the late 1980s to come in for a "special shoot" with no further details.

It turned out the Gardens had rigged a proposed location for new private boxes, with workers sitting out on the scaffold to test the sightlines. Ultimately, a few rows of greys would have to be ripped out to accommodate the new suites.

45

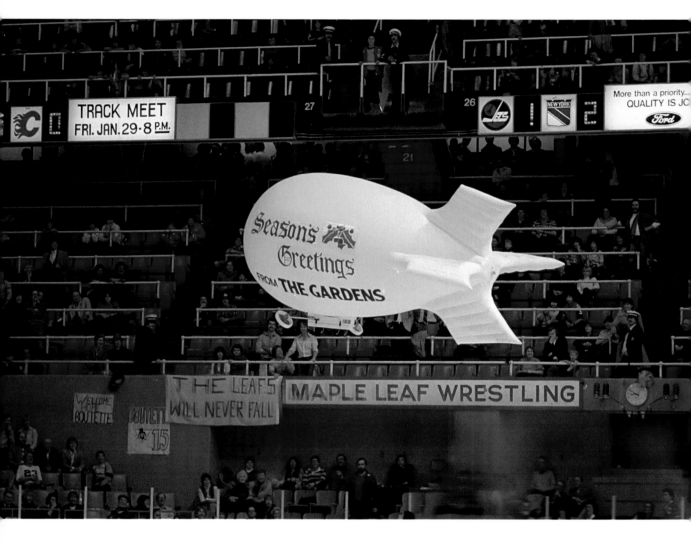

This picture from 1980 tells you a few things about the Gardens. You can see how full it is for a Leafs game, the signs for the upcoming track and field meet and wrestling cards, plus the old out-of-town scoreboard. And there's a sign in the corner welcoming back Pat Boutette, who'd been traded to Hartford a year earlier.

The Gardens had enough ceiling room that a real blimp could have fit in. Then again, a game in Buffalo was once delayed when one of these remote-controlled airships stalled and got stuck about 20 feet above the ice. —L.H.

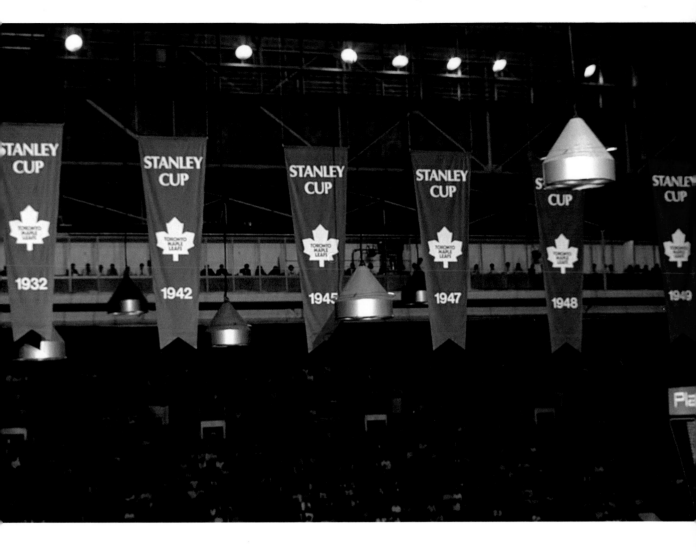

have some good memories of the championship banners that used to hang in the 1960s before Harold took them down.

So it meant a lot to fans to see the new blue ones go up in the early 1990s. But the longer the Cup drought went on, it started getting tough to look up. You went to Detroit and Edmonton and those arenas were covered in banners.

Then again, some teams can go overboard and put up banners for the smallest of accomplishments, such as a division title. I was glad the Leafs never did that at the Gardens after they won the Norris in '93.

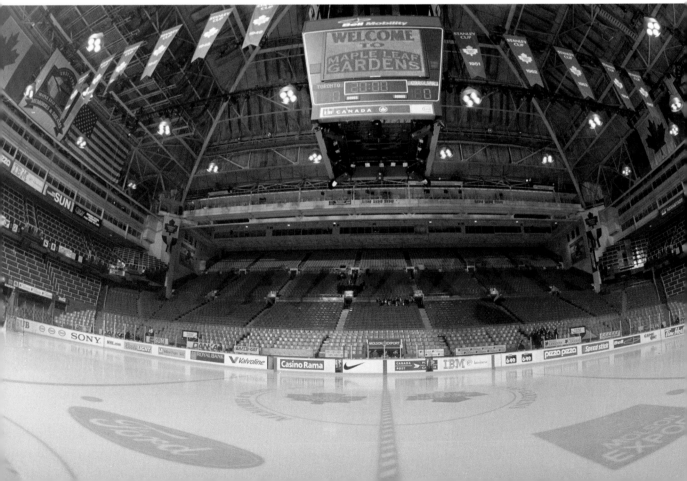

This photo is from a game on New Year's Eve, 1983, a 5–3 win over the Los Angeles Kings. The game was played earlier in the day so people could go and still celebrate the new year that night. There wasn't much to celebrate that year. The team won just 26 times.

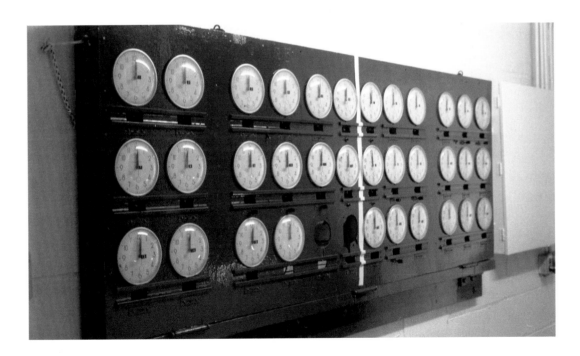

No, it's not the engine room on a steamship; this is where staffers used to calculate game-night ice time for individual Leafs.

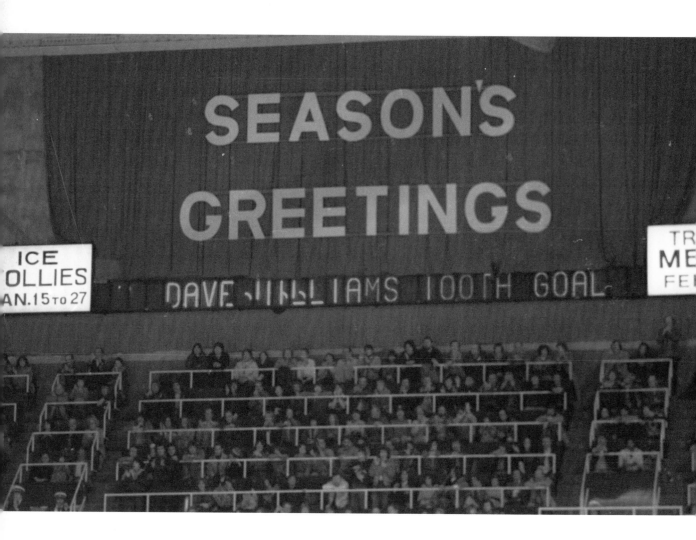

SEASON'S GREETINGS

DAVE WILLIAMS 100TH GOAL.

ICE FOLLIES AN.15 TO 27

TR ME FE

Before the video scoreboard age, there was just an electronic message sign, like the kind you see in Times Square.

Damn if every picture I took of it, there was either a letter missing or half a letter not lit. It would be hard to decipher that some player scored his 100th career goal.

I remember the alphaboard that displayed messages like "Go Marlies Go" and "Go Leafs Go" would get the crowd going, long before canned music and other gimmicks. It also gave fans a reminder of the goals, assists and penalties, if they had missed Paul Morris's announcements.

But Graig's right, there were some embarrassing moments, such as when defenceman Jim Dorey's name rolled out as "Jim Dopey." –L.H.

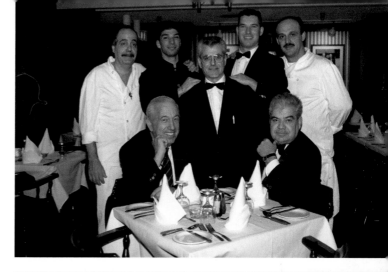

The Gardens was full of people who came from all walks of life. And it seemed a lot of them spent their whole life at Church and Carlton.

It was said you couldn't get fired from there unless you really messed up—it had to be something big, like forgetting to take Harold's dog for a walk.

The joke among the ushers was that anyone in their 60s was a junior member. Some of the ushers were so old that I don't think they could have done anything in a real emergency. But they were great people.

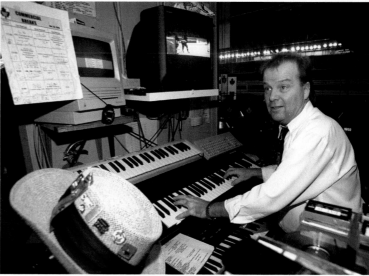

Harold knew everyone in that place by name. And a lot of people who stayed were able to get their family members a job there, too. It was who you knew that counted (hey, my son freelances for the Leafs). I got to know characters such as Cigar Freddy, Jimmy the Puck Guy, Sam the Zamboni driver and "Black Jack," who walked around the Gardens wearing a referee's sweater and was "adopted" by the real officials as you see in this photo.

Then there was the guy they called Pops, the ice cream salesman. I took this one of him

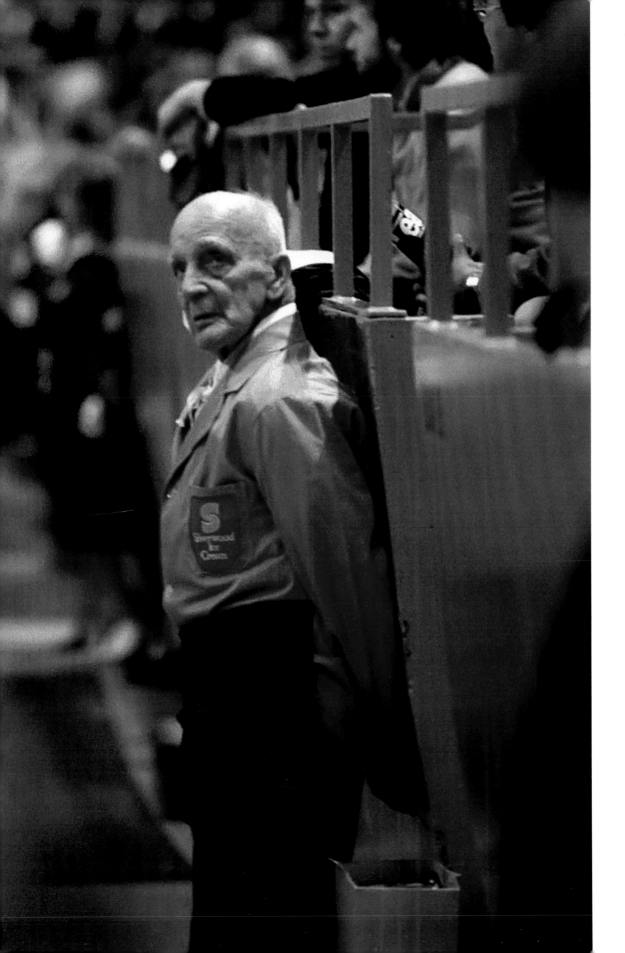

on October 21, 1981, a 4–4 tie against the Colorado Rockies. Pops was taking a break to watch a bit of the action. Many of these guys had day jobs or no jobs and weren't paid well for working the games. But they kept coming back anyway, for the love of the Leafs and the love of the Gardens, even if they couldn't see much of the game.

They changed their uniforms through the years, but the usherettes were always part of the tradition in the Gardens' lower bowl and were always nice to me.

Except the one who tried to have me thrown out one night. She had just started on the job and all she knew was that I was some guy with a flash camera where flash cameras weren't allowed. I tried to explain the flash was coming from my strobes in the rafters, but she didn't understand. When I started getting mad so did she, and she tried to escort me out, until I told her to get her supervisor.

We can laugh about it now, because she's still working at the Air Canada Centre.

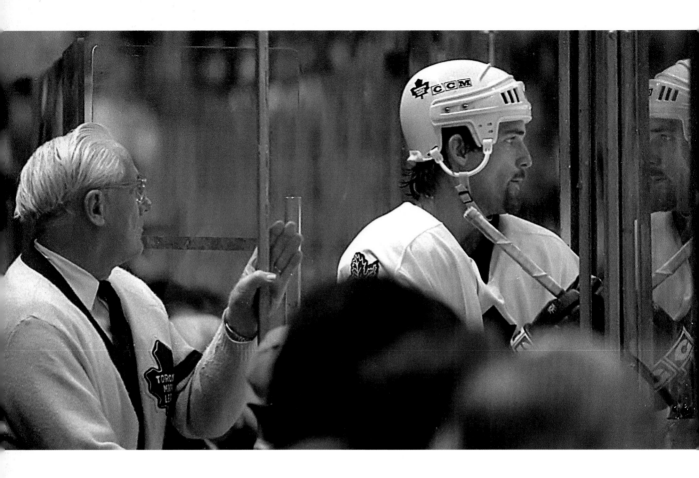

Jimmy Connolly was one of my favourite Gardens personalities. By day, he worked at Eaton's department store downtown and on game nights, he hung out with us in the photographers' room. He'd always be wearing this white sweater with a Leafs logo from the 1960s. He played cards with Ace Bailey, the timekeeper, and with Black Jack.

That game quickly ended when it was time for Jimmy to get the pucks ready. He kept the pucks frozen in a bucket of ice cubes to give to the timekeepers and, man, he took his job seriously. He also collected game pucks from around the league that other teams inadvertently brought to Toronto for practice. If he had duplicates, he would slip me one now and then for my own collection.

Toward the end of the Gardens' days, they kicked him out because he wasn't an NHL employee. That must have broken his heart. But they brought him back for the closing and this picture is from his big night. He was so proud.

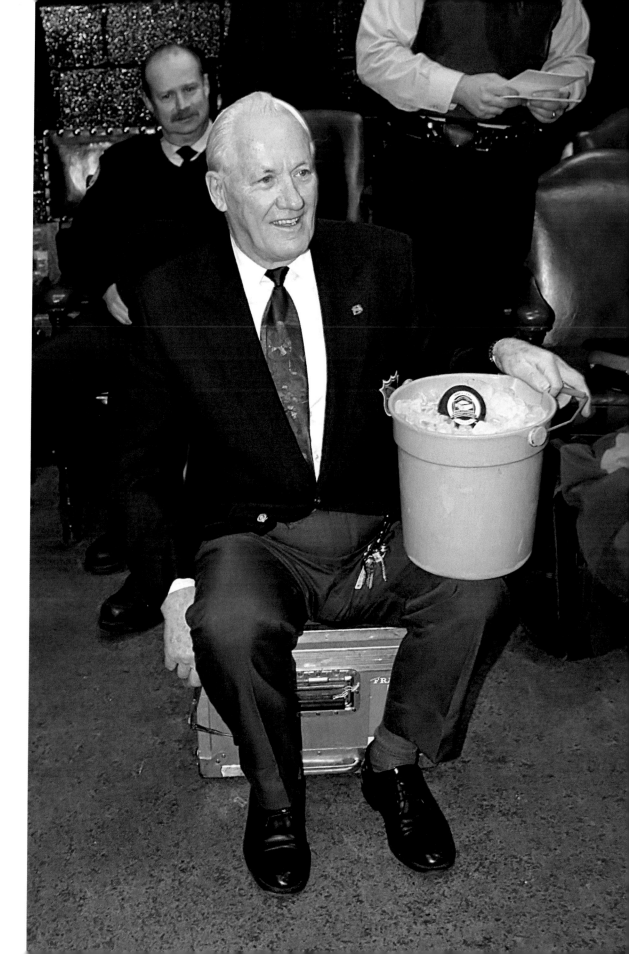

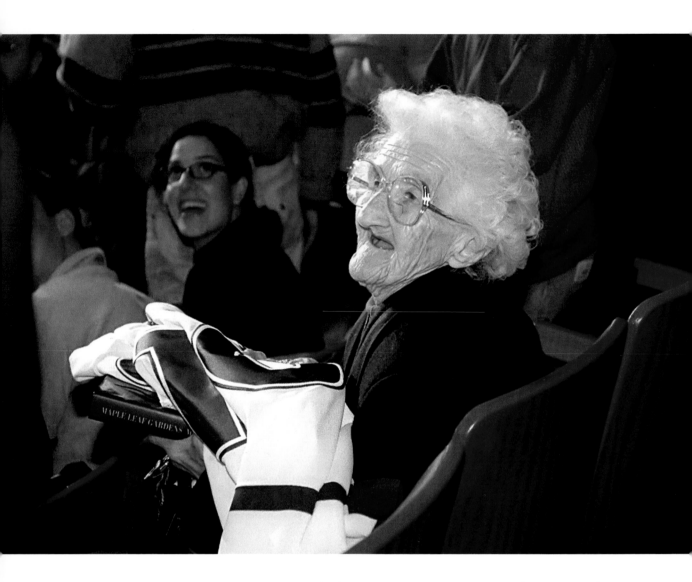

Bessie Lamson worked in concessions on opening night in 1931 and they invited her back for the closing. She was given a No. 100 Leafs sweater. She came back every year on her birthday after that. Darryl Sittler would appear at her seat during a timeout and they'd show him giving her flowers.

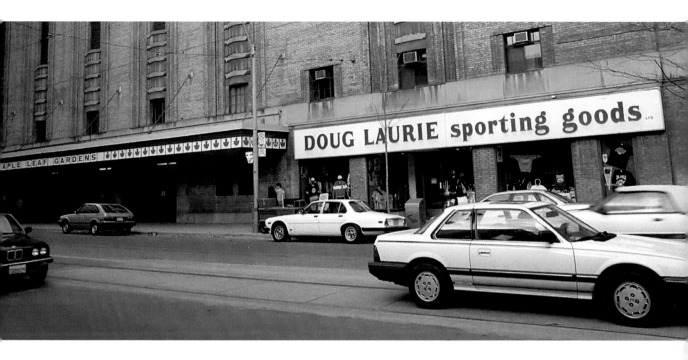

For a time, Doug Laurie's store was the most famous Leafs souvenir shop in town, basically because it was the original and the only place to get items such as pennants and authentic numbered Leafs sweaters.

The other big business out of there was game-used sticks, which often came right from the rink the night before. It used to be people like myself had our pick of the sticks. My coaches would tell you I shot equally bad from left or right, so it didn't matter if I had inherited something from Rick Vaive or Börje Salming.

We could get them for free, but someone in the Gardens decided to get crafty and sell the broken sticks in secret out the back door. Harold found out about that black market business and decreed they would be sold in Doug Laurie's from then on.

You could always count on Laurie's—or Leafsport as it was later known—to be packed on game night.

My mom bought me a replica Eddie Shack Leafs home sweater at Laurie's in the early 1970s. The first time we washed it, the blue bled into the white and I was inconsolable. We eventually had it fixed at the cleaners and I wore it until the arms wore away and I converted it to a cut-off baseball sweater. —L.H.

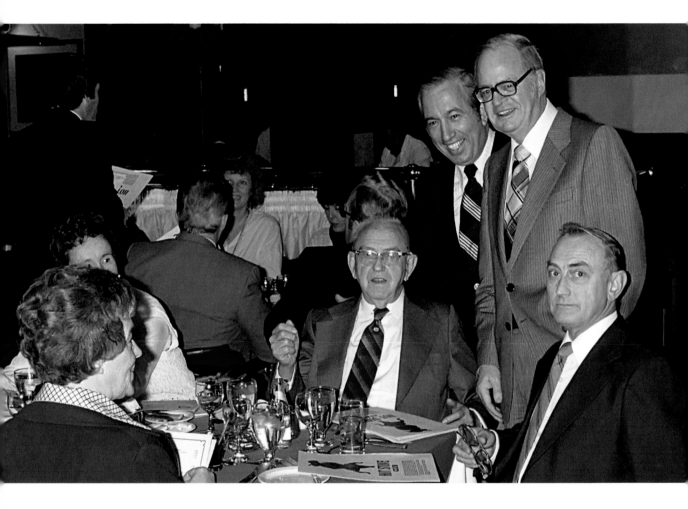

This is a very rare picture of both Frank Selke Sr. and Jr. in the Hot Stove around 1979. The elder Selke helped build the Gardens and ran it during Conn Smythe's absence during World War II. He and Smythe fell out, and Selke departed and went on to great years with the Canadiens. The younger Selke was also influential in Montreal and later ran the Oakland Seals before getting into broadcasting.

Nick, the Hot Stove *maitre d'*, got the two of them to pose with the president of Molson's, a really big deal that everyone wanted me to record. Only when I got back to the shop did I realize I hadn't loaded my film properly and there was nothing on it. I phoned Nick and admitted right away that I'd screwed up.

God bless Nick for telling the Selkes someone broke into my car and stole the film and they arranged to take the picture again the next time they were in town together.

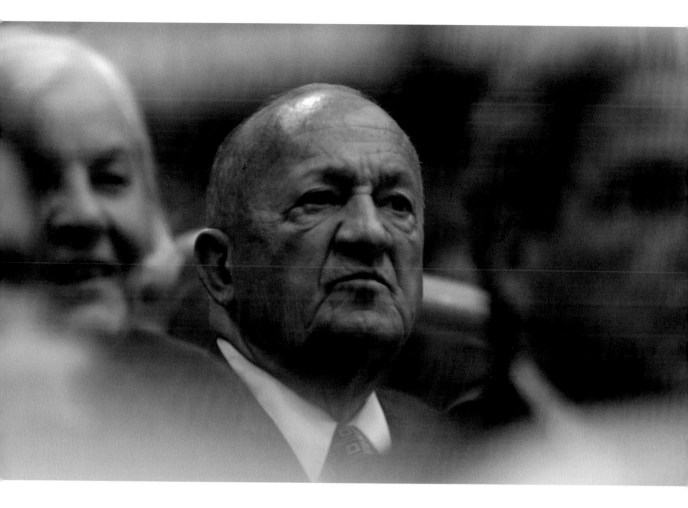

When Steve Stavro took over the Gardens in the early 1990s, he would entertain in the directors' lounge on a regular basis. Stavro and Chas Abel Photo actually went back a long way. He and his relatives had dropped off film at our front counter for years. Our family actually went into business with him by opening our Snap Shops photofinishing booths in his Knob Hill Farm grocery stores.

Right from the start, we got along well and we became good friends. Whenever he wanted a photo, he would call out, "Get Abel in here!" Apparently, I never had a first name. But unlike Ballard, he stayed out of the spotlight. He very rarely walked out on the ice for a ceremony. His seats were behind the penalty box, which made it tough for me to shoot any of his special guests because it was directly in my lights and the exposure wasn't the best. There was always some celebrity, politician or a medal-winning athlete in attendance.

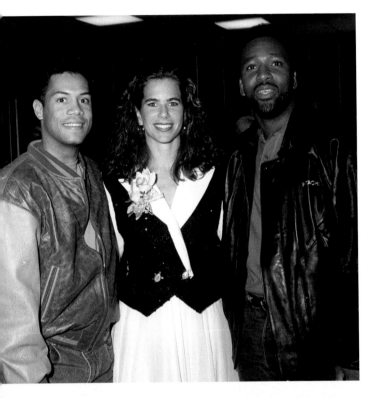

For some reason, Mr. Stavro would always have a cake made in honour of the guest that was present. Whether it was their birthday or an acknowledgement of some achievement, any time there was a cake presentation, the call would come down the hall for me. It was a thrill for me to get into the lounge and mingle with people like Olympic athletes, the mayor, Toronto VIPs or movie stars.

Sometimes the guests would come up and talk to me about how amazing my job must be. I always told them that everyone has at least one thing they do well and mine was photography. But if they were an

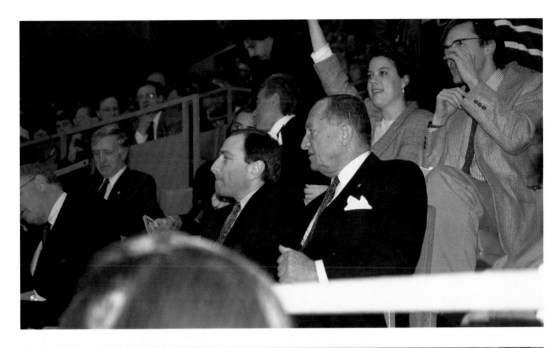

athlete, I'd point to their medals and remind them they didn't just do well, they were the best in the world.

The only time Mr. Stavro didn't have me in the lounge was when the Prime Minister came. The PM brought his own official photographer. But Stavro always bought extras of my prints.

worked many press conferences in the Hot Stove, everything from Wendel Clark's signing to the dismissal of a coach or two.

There were the usual nice things said: "He'll be an asset to the team" or "We are pleased to be able to sign" or "This young man is an up-and-coming, future star."

When you shoot these events, you have to get a shot of the club official making the announcement and shaking hands with the new player, who then puts on a Toronto sweater. Everybody is all smiles and you take a few more at the end. All of the talk in the middle doesn't really matter to me. But there was one event where I wished I'd paid attention.

Let me explain by saying two things were sure to happen at a Gardens presser: the Hot Stove would have great sandwiches for the media, and when Ken Dryden was making an announcement, it would be a long talk about nothing. So when he was president, I'd reserve my spot in the front

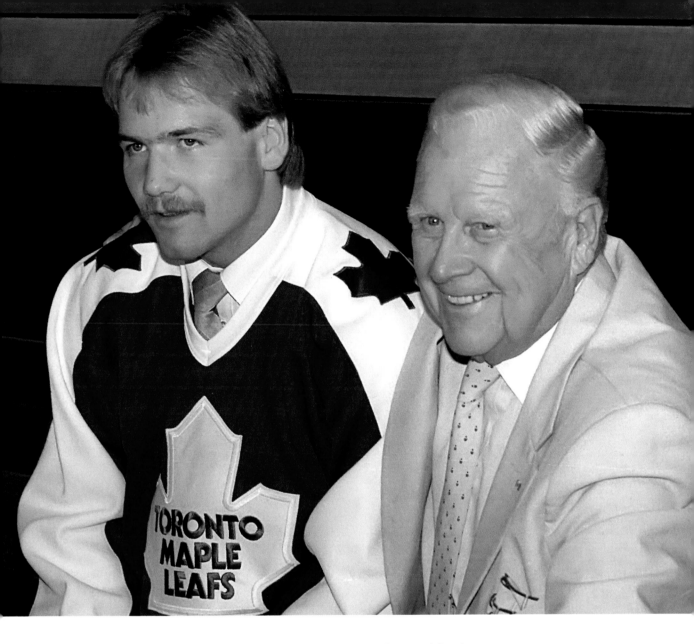

row, grab a plate of sandwiches, take a few Dryden shots and finish eating, knowing I had some time before the subject was introduced.

But on one occasion, I didn't notice the couple of TV cameras that were filming the front of the stage had begun panning away from the podium where Dryden was talking. They focused on the first row where I was grazing. When the 11 p.m. sportscast came on, there I was, gobbling my lunch and looking like I cared more about the roast beef than Dryden's speech.

I got a bunch of phone calls and comments from friends and co-workers about how tough my job must be . . .

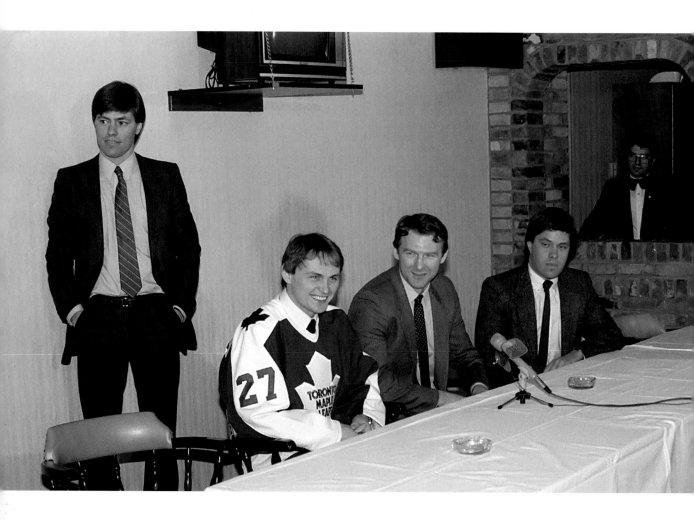

This is the press conference announcing Miroslav Ihnačák's signing with the Leafs, one photo the club probably wishes Graig would rip up.

Now Peter Ihnačák, seen here on Miro's right, was very personable for a newcomer to Canada and played well, with 66 points his rookie year. But poor Miro was miscast as a saviour, and the Leafs paid almost $1 million to spring him from Slovakia in the bad, old Iron Curtain days. He couldn't live up to the Stastny-level hype, starting with the heavy No. 27 the Leafs unwisely assigned him.

Some important Gardens press conferences were routine affairs, others were done on the fly—such as the hiring of coach Tom Watt after Doug Carpenter was fired in the autumn of 1990. Cornered by the media in the west corridor about Watt moving from assistant to Carpenter's replacement, general manager Floyd Smith insisted he had several candidates to speak to, then escaped to his office upstairs. It couldn't have been a very long list, because 90 minutes later, Smith came back down to announce Watt was taking over.

Then there was the dressing room reaction to the record 10-player deal with Calgary that Cliff Fletcher made to revamp the Leafs for their 1990s turnaround. Each stunned Leaf asked us to repeat the names involved, not believing such a large-scale transaction was possible.

A few months later, we were back in the Hot Stove for Pat Burns' introduction as coach. As a joke, the press gang planned to ask Burns the first question in French, since the Quebec media had made life so hellish for him during his last days in Montreal. But we chickened out, already intimidated by the ex-cop's demeanour. Burns would rattle many Leafs that same way in the coming months.
—L.H.

The press box on the upper east side of the Gardens had a number of functions: it was for reporters, radio broadcasters, television, scouts, the organist, off-ice officials and special guests. Leafs management had a private booth in the southeast corner.

I took this photo of Joe Bowen and Gord Stellick after I was interviewed on their radio show, which turned into a funny story.

Joe had asked me for some 8 x 10 prints of some players. Rather than pay me, I just asked if he'd mind promoting my work on the air. Joe did one better and invited me on air as an intermission guest.

I get nervous in front of a big crowd or a microphone and I was already out of breath from rushing upstairs between periods for the interview. Joe put me at ease by telling me to imagine it was just a casual conversation between the three of us. It was actually going well, with questions about how I started, how long I'd been there, who my favourite Leafs were, that kind of thing. Until he asked where my designated spot was to take pictures.

"Over there," I said cheerfully, pointing to the corner.

I couldn't understand why Joe was frowning—until I was told at the break that pointing doesn't translate very well on radio.

Before and after commercial breaks, Joe told his audience they were listening to "Graig Abel from Chas Abel Studios," while plugging the intermission sponsor, Black's Cameras. I started laughing because we didn't have a studio; we were a photofinishing company. And some years earlier, Chas Abel and Black's had merged on the Toronto stock market and then broke up the deal on bad terms. So here I was, Graig Abel from Chas Abel, with everyone listening to a show sponsored by our rival.

recall the snickers from the older reporters the first time I went into the press box around 1984 to do the sidebar of a Leafs-Penguins game. My shaggy hair contrasted with a three-piece powder blue suit, the only one I owned; I had figured that everyone dressed their best on game night.

The Leafs lost that night, but I was sent to the Pittsburgh room and wrote about winning goalie Michel Dion. In the next 15 years, I covered the Leafs in their best and worst lights, saw them sink so low that fans threw sweaters on the ice in disgust and play so well they captivated the entire city.

I saw leads blown, chairs thrown, trades made and careers crushed by injury. In '93, they played 21 playoff games in 42 nights and it seemed like I lived in the

press box. There were nights I couldn't wait to leave the Gardens, days when I was barred and endless hours waiting for the Leafs room to open to the media. I chased players and executives down the halls, up the stairs and into the parking lot or dodged other reporters in a cat-and-mouse game for scoops.

My colleagues at the *Sun*, *Star*, *Globe*, Canadian Press and *Hamilton Spectator* weren't too far ahead of the typewriter era when I started. We began with an early crude computer called a Teleram that weighed a ton and transmitted painfully slowly on a tiny screen. It had sensitive acoustic phone couplers that always disconnected if there was loud crowd noise, which was usually a late goal on deadline. But before the Gardens closed, we were all using laptops that sent stories with the click of a mouse.

After the Gardens closed, the club provided a unique souvenir for all media, a monogrammed container of melted ice from the last game and a slice of the Formica press box table with our assigned number, autographed by Wendel Clark.
—L.H.

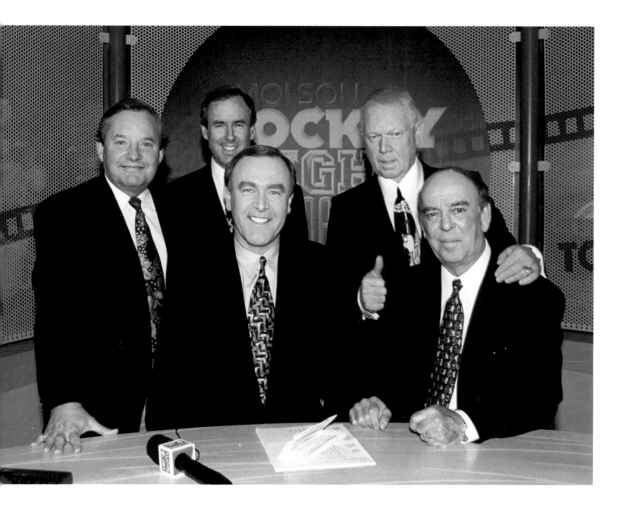

When you saw the *Hockey Night in Canada* studio on TV, it looked beautiful. You thought it was this magnificent studio and you wondered how carefully it must have been put together. In reality, it was a really dumpy-looking room under the stairs, with a tiny makeup table for the on-air crew. It was dark and grim with cables running all over the ceiling.

But it was right across the hall from the Leafs dressing room, a really convenient spot. And it was home to all the famous *Hockey Night* people, Dave Hodge, Harry Neale and Don Cherry. They were really down to earth when they talked to you individually, but as soon as two or three of them got together, they acted like big-time TV guys.

It was a sign of the intimacy of the Gardens that the *Hockey Night in Canada* studio was directly across the hallway from the Leafs dressing room, and their tech trucks would park right outside on Wood Street. Today, all the network studios are off-site.

"What happens in the studio is a microcosm of the Gardens," executive producer John Shannon once said. "It's hockey and fantasy mixed together." —L.H.

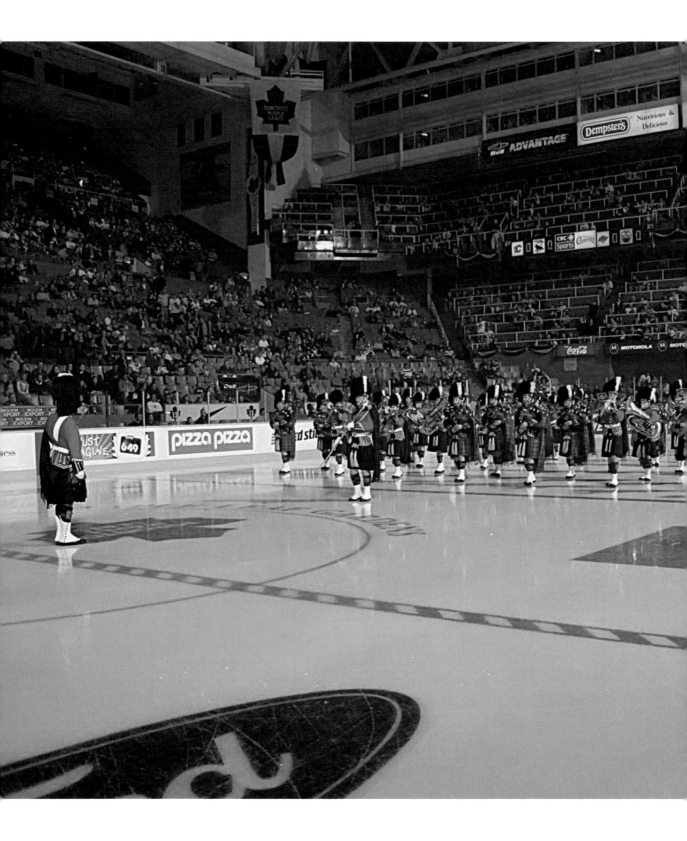

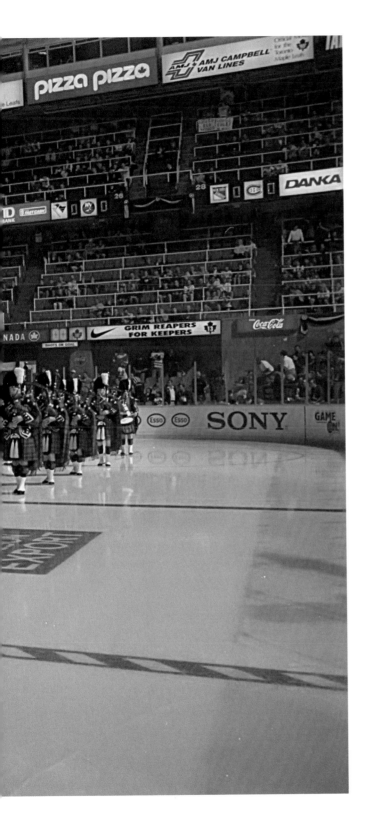

always liked that the 48th Highlanders pipe band played the opening of every season in October. Hearing "The Maple Leaf Forever" was when you realized the Leafs season had really started.

I would chat with them before they went out each opening night and they were really great people. There were some issues with them slipping on the ice, but after a couple of them had nasty falls, they started attaching little cleats to their footwear.

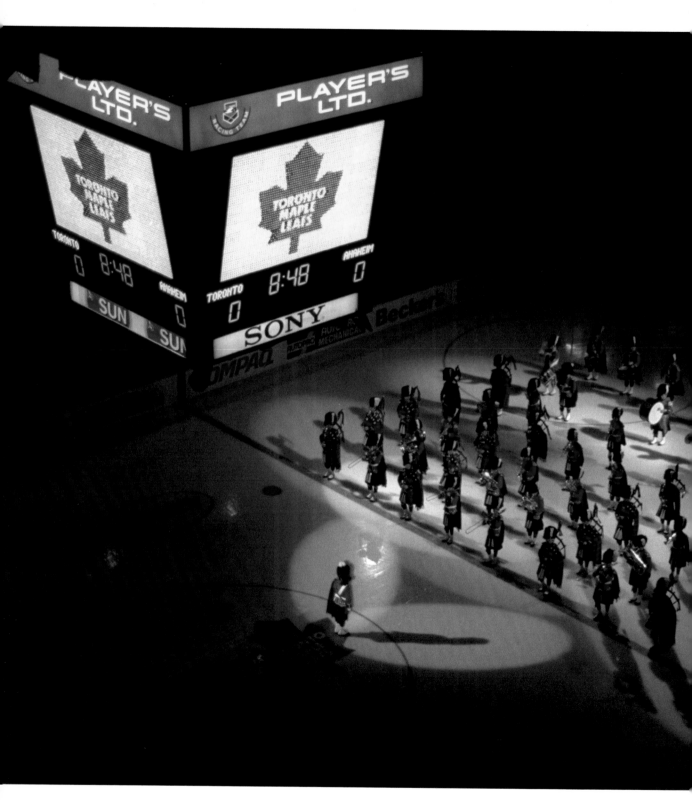

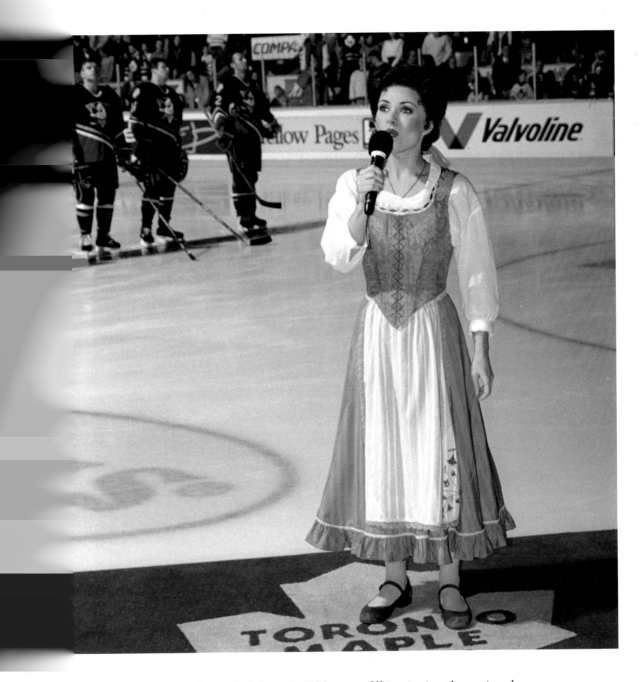

'll never forget the night I thought I'd have to fill in singing the national anthem.

The Leafs would bring in all sorts of singers for this ritual: pros, amateurs, the actress who played Snow White on stage, the Mistletones at Christmastime, the Barenaked Ladies and the "regulars," like John McDermott and Michael Burgess. If there was a new play or musical

running in town, often one of the singers would perform "O Canada," "The Star Spangled Banner" or both.

For me, having new singers was a guaranteed sale of a souvenir print, so I was always on time and in position. I especially liked when there was a group performing because that meant more prints.

One night, the singer was a young lady from the Toronto Police Services Board, who was introduced and proceeded out onto the blue carpet that

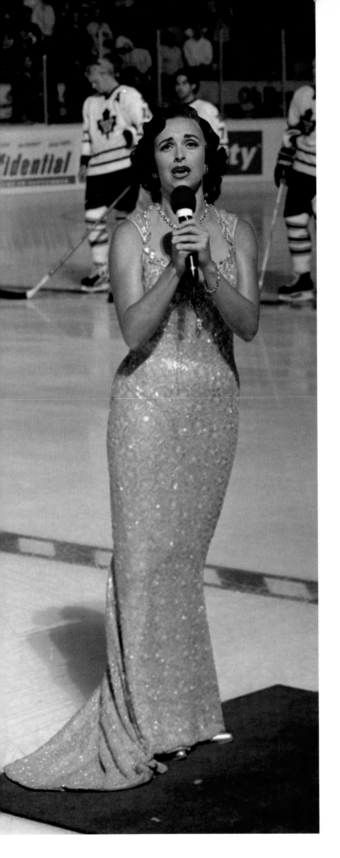

led from the penalty box door about 20 feet toward centre ice. I followed her and stood right against the boards near the end of the carpet. I never liked going out on the ice as I always felt that if I ever slipped, 16,000 people (and maybe hundreds of thousands more on TV) would be watching.

I can't imagine how hard it would be to have to sing if you were not a professional.

I would hang back a bit until the singer got comfortable with the first lines and then move up in front for a few shots. But on this night, the poor woman got tangled in her lyrics and then just stopped singing. She forgot the words. She started over again, and I let her compose herself before going back in her line of sight. The last thing I wanted to do was make her more nervous with a camera pointed at her. She started again but stopped cold.

At this point, I was about 15 feet away, and she looked right at me as if to say, "Can't you help?" I looked past her to the Leafs bench and the players were howling with laughter at the screwup. She gave it one more try and by this time the whole building was laughing. She ran off the ice and locked herself in the directors' lounge. I felt bad, but if I had sung, I would have cleared the whole building.

I never did get her photo. I think after that episode there was more auditioning before anyone was allowed to sing at a game.

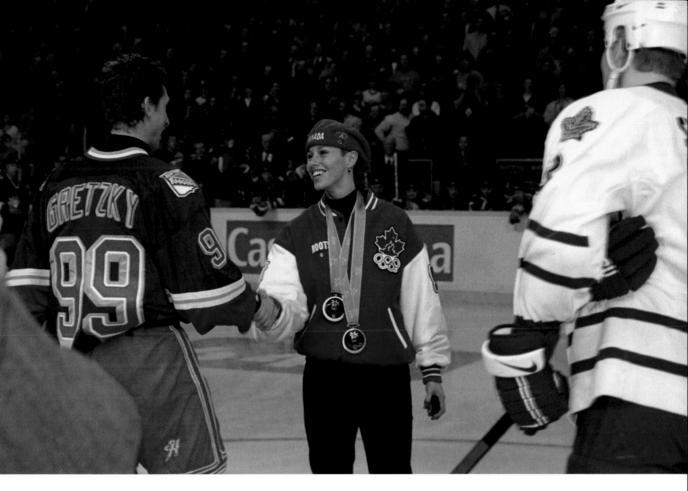

M r. Ballard liked to haul people out to centre ice for puck drops before the game. This was another cash grab for me—the more the merrier, and the more prints I would sell.

He would bring out sports figures, celebrities and medal winners, while I'd count dollars in my head and think, "Geez, if they bring out the whole Canadian Olympic team one night I can retire."

The usual routine was a carpet laid along the centre red line to the dot and a smaller one put down to make a T formation. That way a group could stand at centre and drop the puck on the dot. Quite easy for most.

Ballard asked Ben Johnson to drop the puck for the season opener, a few months before his troubles in Seoul. With both men dressed in tuxedos, Ben was introduced, out they went, and I followed behind to set up. The two team captains were called for the faceoff, but speedy Ben hadn't stopped at the dot. Unfamiliar with hockey's faceoff ritual, he turned and went to the end of the carpet where he was facing one of the goalies. Both captains kind of looked at each other, then at me and thought, "Oh well, it's Ben Johnson" and they moved to where he was.

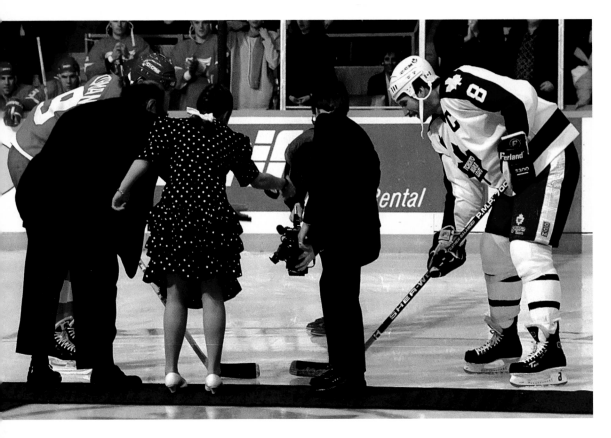

He dropped—almost threw—the puck quickly on a patch of bare ice. I could have done my best Big Ben sprint over there to get in front, but as every Canadian knows, fresh ice in dress shoes means disaster and I wasn't taking that chance. I took the photo while standing on the actual centre dot, capturing the moment, just not quite as planned.

One Remembrance Day, I was asked to photograph members of the Canadian military coming out for the pre-game ceremony. I walked out from the penalty box side to shoot as they entered through the players' bench as planned. But instead of facing me and the TV cameras, they all turned and faced the flag that was hanging at the south end. You can't really blame them for following instinct.

Colleague Dennis Miles and I looked at each other, but neither of us wanted to make that mad dash to the other side of the rink on fresh ice. There were no extra photos to sell that night.

Rick Vaive's 50th goal was one I didn't want to miss, the first 50-goal season in Leafs history, March 24, 1982. The only thing I was sad about was that my childhood hero, Frank Mahovlich, had not done it first. Vaive's goal came near the end of a long, losing season for the Leafs and there wasn't a lot to get excited about until he hit 49 goals and the Blues came to town.

I set up as far back as I could get before the game, moving slightly behind the goal line. I had two cameras that night, my standard 80-200mm lens and a wide angle. Whenever Vaive was out, I had the wide angle. I was at the Blues' end for the first and third periods, and when he didn't score in the first, I was praying he wouldn't do it in the second when I was at the wrong end of the rink.

I was cheering for him to score the big goal at home in the third and wound up with one of the best pictures I ever took. You can see Rick shoot, the puck going in the net and goalie Mike Liut of the Blues look behind. Vaive's linemates Dan Maloney and Bill Derlago and the rest of the Blues, plus referee Kerry Fraser, are all in the perfect position. There aren't many times you can capture Leafs history like that.

Rick and I have been friends ever since.

The *Toronto Sun* had a clever headline the next day: *Me and the boys and my 50*. It was a take on the famous Labatt beer ad of the time. Mickey Redmond and Bobby Hull had their 50th goals at Maple Leaf Gardens before Vaive, who did it three times overall, twice at home. Gary Leeman and Dave Andreychuk also had 50 for the Leafs.

Of course, Vaive wasn't the first pro player at the Gardens to get 50. The WHA Toronto Toros had a sniper from Bowmanville, Ontario, named "Shot Gun" Tom Simpson, who reached 50 in style in the spring of 1975 with a hat trick that moved him from 49 to 51. Vaclav "Big Ned" Nedomansky had 56 for the Toros the following year. –L.H.

At the beginning of the '92–93 season, I upgraded to big strobe power packs so I could get more juice and more light.

I had a great system worked out. All Leafs games were on Wednesdays and Saturdays, no exceptions. I bought a seven-day Day-timer and set the lights to go on those two nights at 6 and turn off at 11. No longer did I have to walk up all those stairs to the top of the Gardens twice a night. Everything worked perfect, until the first round of the playoffs. I re-set the timers for the new dates the Leafs were playing at home against Detroit. But in the next round, the Leafs opened at home against St. Louis. Game 1 went to overtime and I was as excited as everyone else when it went to a second extra period as the goaltending battle between Felix Potvin and Curtis Joseph intensified.

Then it hit me that my lights would shut down at 11 p.m. At the end of the first OT, I raced to the top of the building and put the timers back on manual, then ran back to my spot.

My second problem was all the people sitting in front of me and the cameramen on either side. One of my duties on game night was assigning the newspaper guys their positions, but the importance of that evening meant many more than usual were attending and there was already a full house of 17,000 sweating fans.

As I'm only 5-foot-10, I asked the fellow sitting in front of me, whom I knew from talking to him every game, to please stay seated if the Leafs scored. I promised him a photo of the goal. Play was in my end during the second OT and I'd switched to a wider lens than usual and shot horizontal instead of vertical. All those details were rolling around in my head, and I was also thinking about the four-second recycle on my strobes between shots. That's when Gilmour got the puck and started weaving behind the St. Louis net.

When he came out on my side, he shot, I shot and the building went crazy. I took some celebratory pictures and tapped my friend to tell him it was okay to start jumping and cheering like everyone else. Everything turned out perfectly, the strobes, the focus, everything. Each time I see the highlight of that goal, I can see my strobes going off, a great reminder of that night.

But I also learned my lesson and set my timers on manual for the rest of the playoffs.

As with Vaive's goal, another Leafs star came through for me to make the perfect picture.

At the moment Mats Sundin scored this late-third-period goal, in a 6–1 win against the Oilers just before Christmas in 1995, Gilmour magically drifted into the frame after setting Sundin up for what would be Gilmour's 1,000th point.

You knew Gilmour needed the big point, so I tried to follow him with the camera all night. And kind of by luck, he came into the picture.

Gilmour thought he had the milestone point two minutes earlier when he set up Mike Craig for a goal. The Leafs stormed off the bench to celebrate, but the goal judge ruled the net was dislodged before the puck entered. Pat Burns couldn't believe Gilmour was denied such a feel-good moment, two days before Christmas with the game already out of reach. Burns waved his hand dismissively at the official as the crowd booed. But Gilmour did get the milestone before time expired. —L.H.

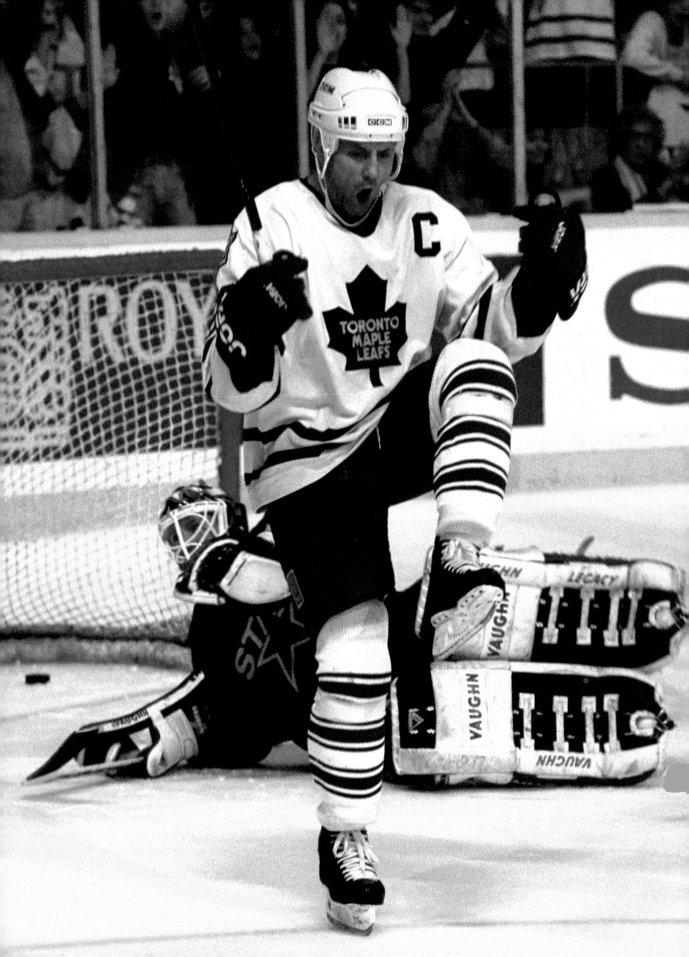

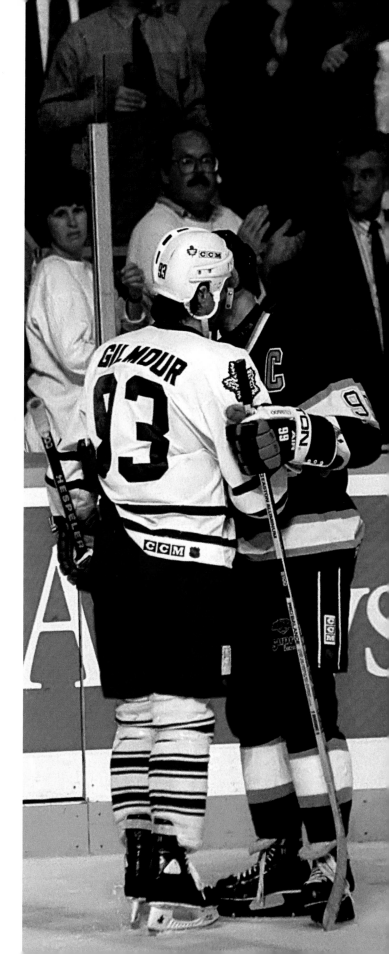

D oug Gilmour was a real treat to watch and to shoot. He had that determination on his face, that look in his eyes. You could tell every game, every shift, he was out there to win. It didn't matter how small he was, no one was gonna push him around. He hadn't been viewed as a leader in St. Louis or Calgary because there were other big players on those teams, but in Toronto you just could sense him say, "I can lead this team."

And he carried them so far.

He was the nicest guy, too. One day there was a row of mentally challenged kids in wheelchairs outside the Leafs room. One player, I won't say his name, just walked past and ignored their autograph books. Doug signed every one and all I heard were a lot of "please" and "thank yous" from the kids. He'd spend a long time doing things like that.

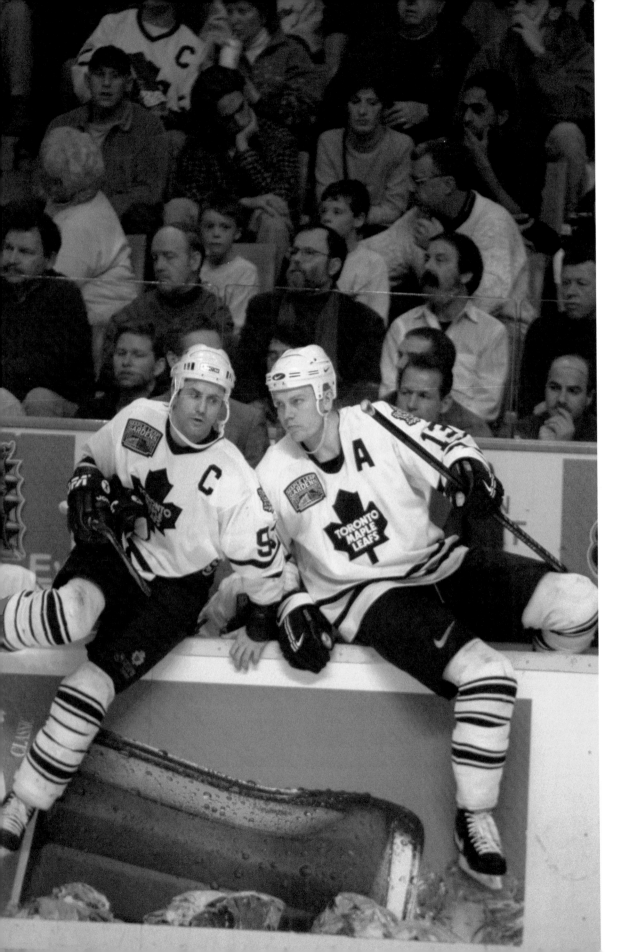

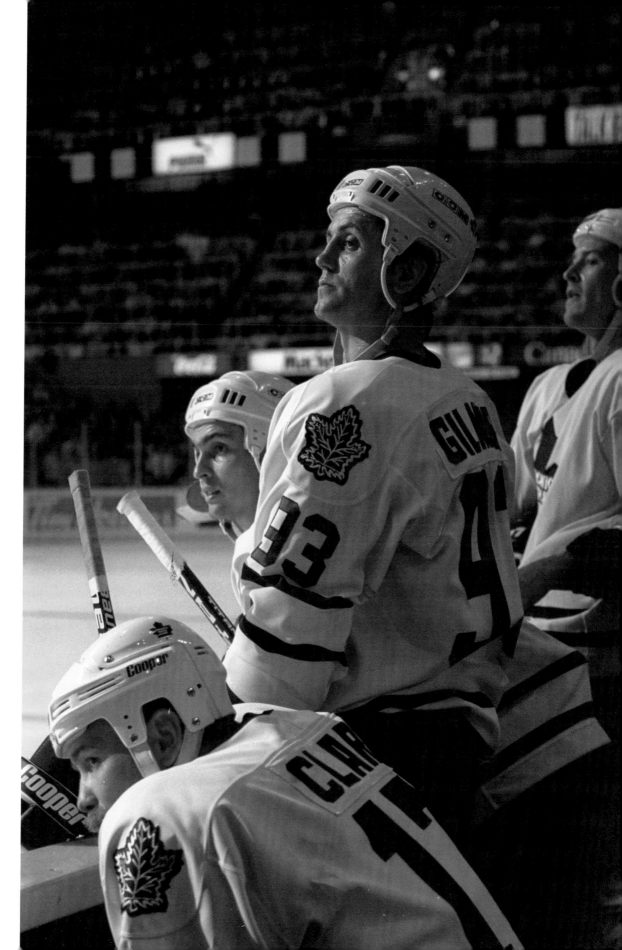

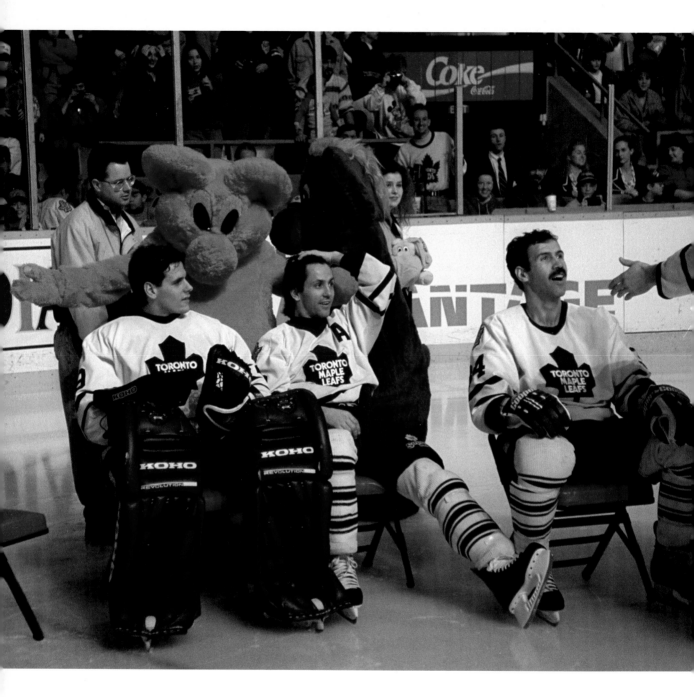

In the second picture, it looks like he's taking on all the New York Islanders single-handedly. That's future Leaf Bryan McCabe grabbing him from behind, ex-Leaf Wendel Clark with Dave Ellett on the ice, and Dougie is swinging at Eric Lindros's brother Brett, who was almost drafted by Toronto.

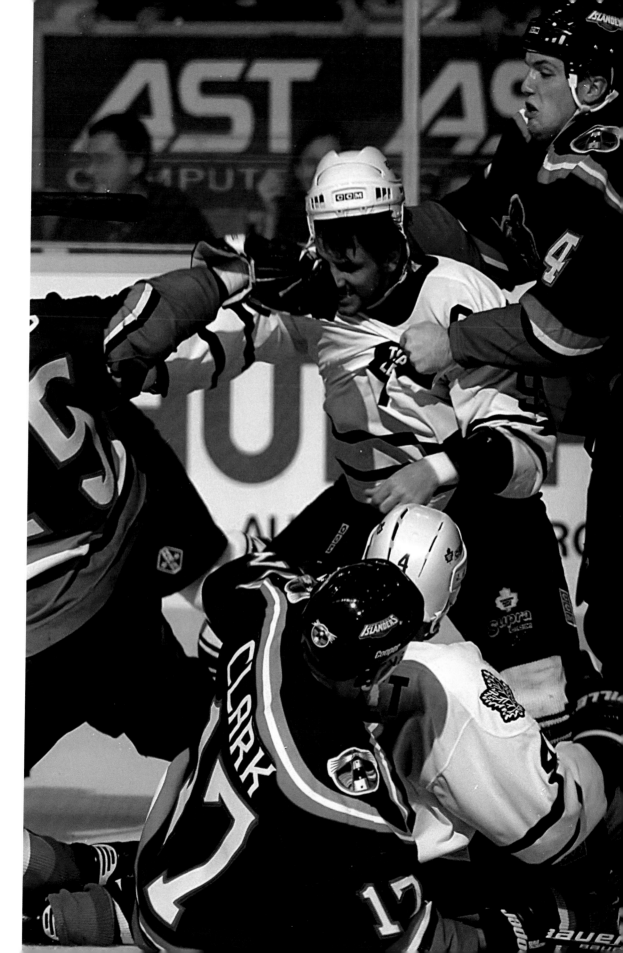

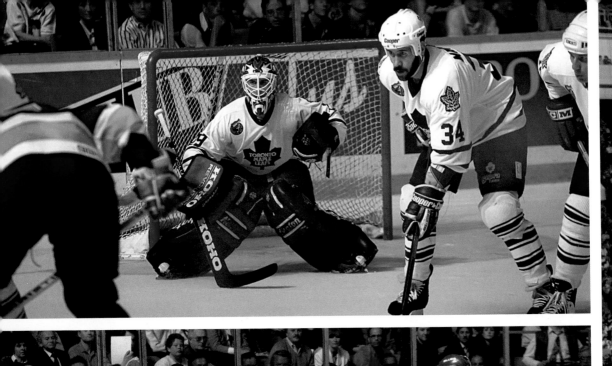

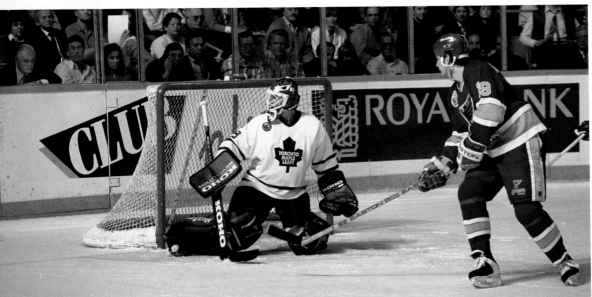

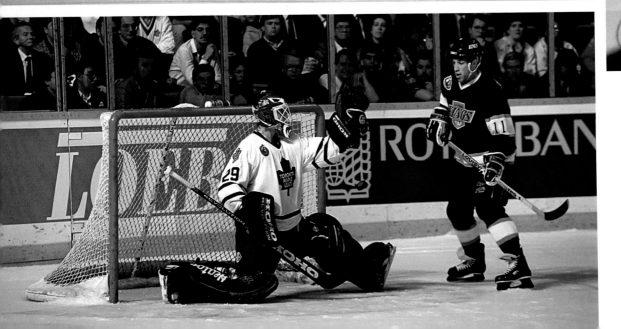

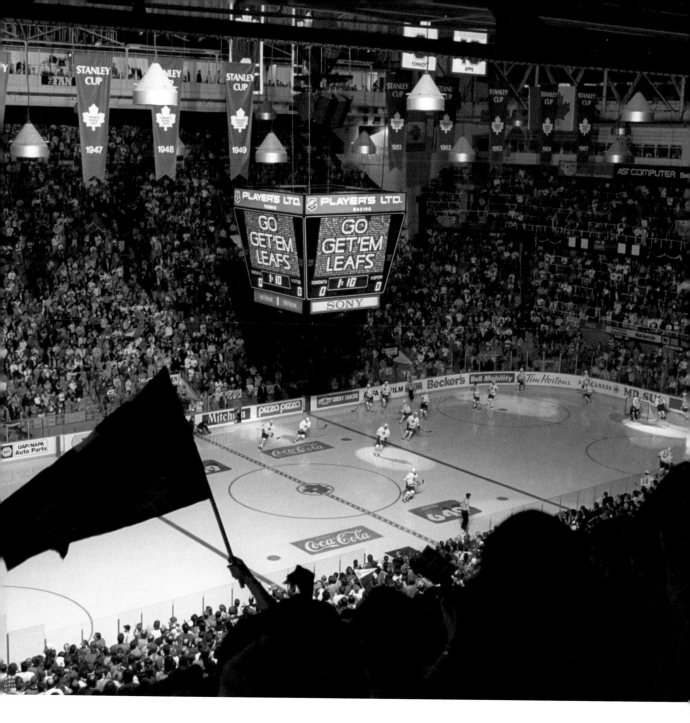

t was hotter than hell inside the Gardens during the 1993 playoff run against the L.A. Kings. In our photo area, there was the glass in front of us and a brick wall behind us so there was zero air movement. Like many people, I had a golf shirt on for many of those games.

But it was fantastic hockey. The place was so electric, from the national anthems when the people brought sparklers, to how crazy the fans got

when the Leafs scored or won a game. I just kept shooting and there was a lot to pick from every night. Even though the Leafs lost in the end, I made sure to get great pictures, such as Gilmour and Gretzky shaking hands.

You don't get to be a fan in this business until you go home and have a beer, and that last loss against L.A. was a tough night for me.

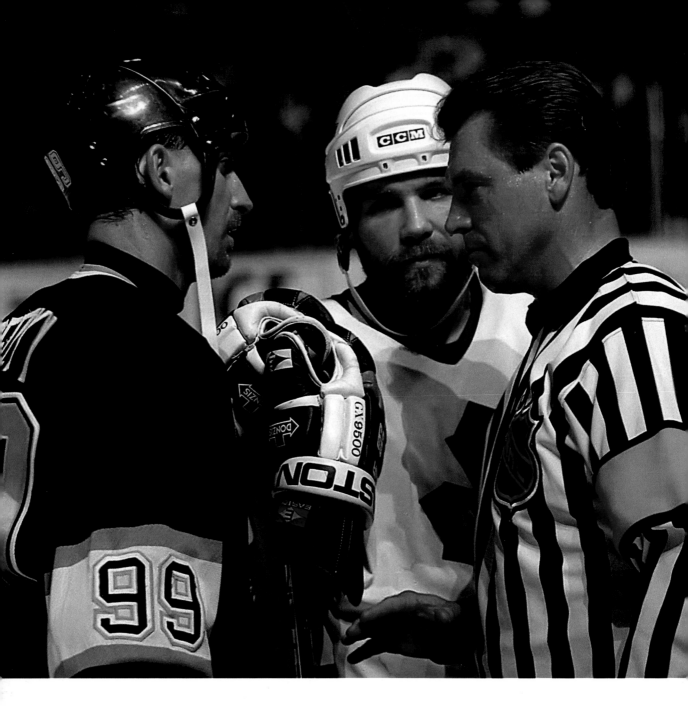

Two famous captains meet at the Gardens during the '93 conference final with referee Dan Marouelli. This photo had to have been taken before the Game 6 blow-up happened in L.A., where Wayne Gretzky high-sticked Doug Gilmour under ref Kerry Fraser's watch and got away with it, which helped change the course of the series.

Though the Kings moved on to the Cup final, both Clark and Gretzky were gone from their respective teams within a couple of years. –L.H.

up of Funds Kings **27** **YELLOW PAGES** **16** Toronto Maple Leafs **Ivy Funds from Mackenzie**

SHOTS ON GOAL **SHOTS ON GOAL**

ZURICH

r Canada **MR.SUB** LOEB ROYAL

Mackenzie Enjoy **Coca-Cola**

When that long '93 playoff run ended with the loss to the Kings, a win away from the Cup final, team owner Cliff Fletcher gathered the media in his office at the Gardens the morning after.

He seemed to want us there to commiserate and catch his breath after 21 games in 42 days. Almost everyone believed the Leafs would have whipped Montreal in the all-Canadian final if Wayne Gretzky hadn't roared to life late in the series.

"Maybe the worst thing about coming this close is that you don't know if you'll ever get back there again," Fletcher observed.

And he was right. Twenty years later, the Leafs have never been so near to the Cup. —L.H.

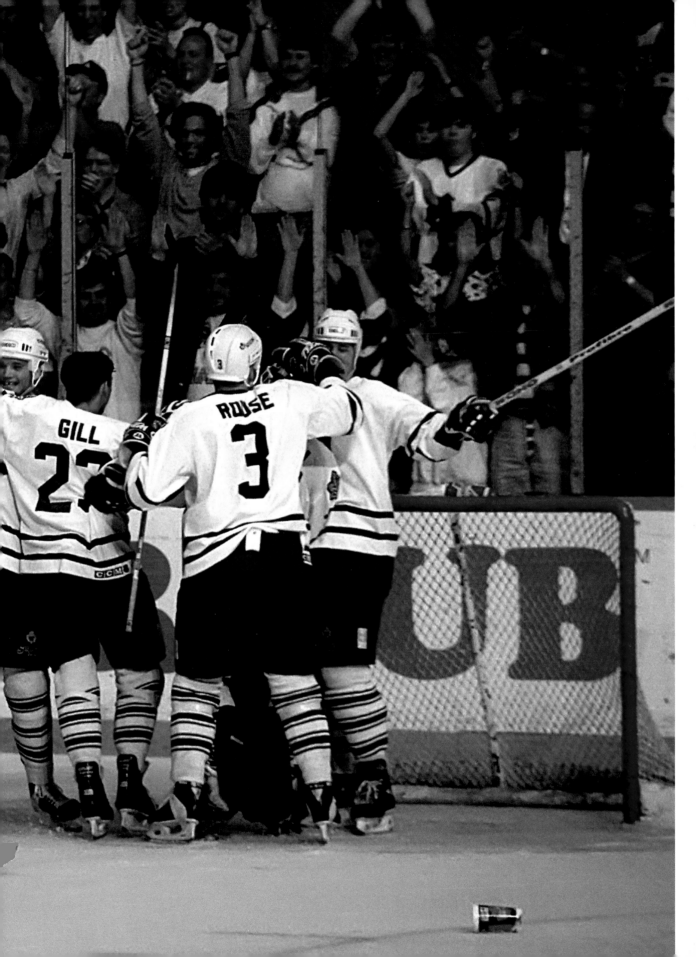

Needless to say it was like night and day when Cliff Fletcher took over from Mr. Ballard.

I liked Harold and always got along with him. But as a Leafs fan it was great to have someone like Cliff, who knew hockey and knew how to talk to people and not piss them off. Cliff always had something relevant to say as opposed to something controversial.

always had sympathy for the Leafs coaches and all the stresses they were under in Toronto.

When I started at the Gardens, Roger Neilson was still coaching. I also went through Joe Crozier, Mike Nykoluk, Dan Maloney, John Brophy, George Armstrong, Doug Carpenter, Tom Watt, the late Pat Burns, Mike Murphy, Nick Beverley and Pat Quinn.

I can't say I had many good chances to shoot coaches from my position because I was looking at the Leafs bench from the furthest side of the rink. But when the Canada Cup was played at the Gardens in the early 1990s, we were allowed to expand our shooting locations and I did get more game shots of coaches such as Murphy and Burns. Maloney and Murphy were really nice; Mike would call you by name, but he also looked like he was under the most pressure of them all.

There was never a hard rule about what coaches should wear on head shot day, so through the years, I got them in a mix of track suits and shirt and tie, depending on what they happened to be wearing. Brophy was probably one of the best dressed of the Leafs coaches. I never saw him in a T-shirt.

On days when I was at the Gardens just to meet people or drop something off, I would hang around in the seats to watch practice and see what kind of drills the coaches were up to. It was always interesting to see something new.

I believe this picture is from the 1993 playoff series with the Kings when Burns was trying to go after Barry Melrose. He was fuming, yelling and screaming. It was a series where you didn't just watch the play, but the benches, too. I knew Burns was trying to put the pressure on himself during that long playoff run and take it away from his players.

I like this picture because you can see Wendel Clark chuckling about the whole thing, while his coach looks like a big rooster going after a hen. Wendel seems to be saying, "Go, Coach, go!"

I also have a soft spot for Brophy, because my son attended his hockey school with some friends in Antigonish, Nova Scotia, when he was 10 or 11.

Did he learn anything?

Well, he did come home with a lot of new swear words.

Pat Quinn served the Leafs as player, coach and GM. Here he's talking to a pair of Kings, Derek (left) and Kris (right).

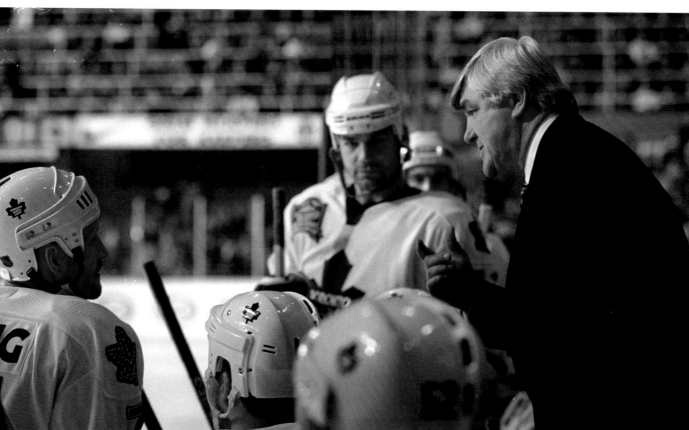

That's Mike Foligno in the foreground with a bubble helmet, with Tom Watt.

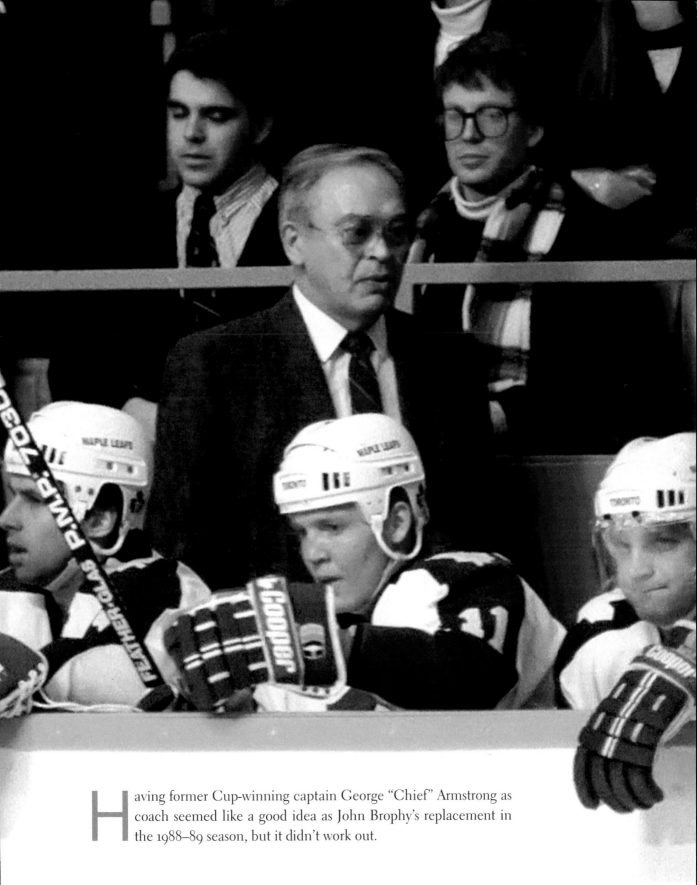

Having former Cup-winning captain George "Chief" Armstrong as coach seemed like a good idea as John Brophy's replacement in the 1988–89 season, but it didn't work out.

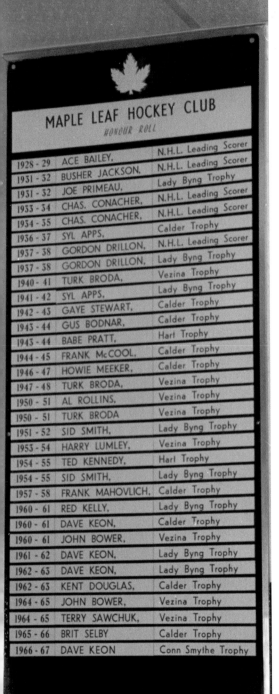

MAPLE LEAF HOCKEY CLUB
HONOUR ROLL

1928 - 29	ACE BAILEY.	N.H.L. Leading Scorer
1931 - 32	BUSHER JACKSON.	N.H.L. Leading Scorer
1931 - 32	JOE PRIMEAU.	Lady Byng Trophy
1933 - 34	CHAS. CONACHER.	N.H.L. Leading Scorer
1934 - 35	CHAS. CONACHER.	N.H.L. Leading Scorer
1936 - 37	SYL APPS.	Calder Trophy
1937 - 38	GORDON DRILLON.	N.H.L. Leading Scorer
1937 - 38	GORDON DRILLON.	Lady Byng Trophy
1940 - 41	TURK BRODA.	Vezina Trophy
1941 - 42	SYL APPS.	Lady Byng Trophy
1942 - 43	GAYE STEWART.	Calder Trophy
1943 - 44	GUS BODNAR.	Calder Trophy
1943 - 44	BABE PRATT.	Hart Trophy
1944 - 45	FRANK McCOOL.	Calder Trophy
1946 - 47	HOWIE MEEKER.	Calder Trophy
1947 - 48	TURK BRODA.	Vezina Trophy
1950 - 51	AL ROLLINS.	Vezina Trophy
1950 - 51	TURK BRODA	Vezina Trophy
1951 - 52	SID SMITH.	Lady Byng Trophy
1953 - 54	HARRY LUMLEY.	Vezina Trophy
1954 - 55	TED KENNEDY.	Hart Trophy
1954 - 55	SID SMITH.	Lady Byng Trophy
1957 - 58	FRANK MAHOVLICH.	Calder Trophy
1960 - 61	RED KELLY.	Lady Byng Trophy
1960 - 61	DAVE KEON.	Calder Trophy
1960 - 61	JOHN BOWER.	Vezina Trophy
1961 - 62	DAVE KEON.	Lady Byng Trophy
1962 - 63	DAVE KEON.	Lady Byng Trophy
1962 - 63	KENT DOUGLAS.	Calder Trophy
1964 - 65	JOHN BOWER.	Vezina Trophy
1964 - 65	TERRY SAWCHUK.	Vezina Trophy
1965 - 66	BRIT SELBY	Calder Trophy
1966 - 67	DAVE KEON	Conn Smythe Trophy

My first experiences with Toronto coaches at Maple Leaf Gardens were through the junior Marlies. Jimmy Jones, Tom Martin and Paul Dennis were all very patient and professional with a young journalist.

But the Ballard era with the Leafs was a lurch from crisis to crisis for whoever was behind the bench. I did enjoy the Brophy years, the last era I recall during which the media was allowed into the coach's office. You entered through an east corridor doorway, but it was not too hard for a passerby to slip in among the post-game crowd. In fact, a bunch of reporters and Brophy were gabbing after one match when we noticed an inebriated interloper at the back, eyeing Brophy's video equipment as his game-night prize.

Brophy hated losing and could curse a blue streak, but some of the most interesting post-game press conferences involve Watt and Carpenter. Carpenter often spoke in riddles, while Watt would go on a rant about the strangest of topics. Such as the night he blamed a loss to Calgary on referee Terry Gregson's being Flames coach Doug Risebrough's brother-in-law.

Later on, Burns proved he could win games and supply post-game zingers. As Graig says, his antics with the refs and opposing coaches were worth the price of admission some nights. Burns often needled his own players—never a bad thing for a writer—and when he saw they were ducking the press, he ordered them out of the shadows to sit at their lockers until we had asked all the questions we wanted. —L.H.

You could just sense with many players that something exciting was going to happen if you followed them with the camera. That was Wendel Clark. Either he'd hit somebody or someone would piss him off and the result would be a fight or a goal. He did a lot of both in his first few years with the Leafs. He was only my height and when you talked to him, you'd never think he could get mad. But boy, he did.

Fight pictures, believe it or not, aren't big sellers for someone in my line of work. Magazine and card companies want crisp, clean vertical action. Of course, you'd try to get a shot of someone landing a punch and some blood, if there was any, but the NHL still has a loose rule that we're not supposed to shoot fights. Few pay attention and shoot them anyway. Sometimes a fight picture is requested if someone is doing a story on violence in the NHL. Otherwise, I'd sit back and enjoy the fight like everyone else.

Here's a classic Wendel post-fight pic, helmet down over his brow, gloves off and that "Don't mess with me" look. You can't see the guy who is down on the ice, but it's actually the former Marlies coach, Dallas Eakins, when he played for the Winnipeg Jets. Dallas hates this picture because he still gets a lot of ribbing for it.

Dave Semenko, in the short time he was a Leaf, was another guy you tried to focus on during a fight. The mean look that guy had on when he went after somebody . . . I'm surprised the other player didn't just skate away. John Kordic, here fighting Jay Miller, was another one. Absolutely nuts.

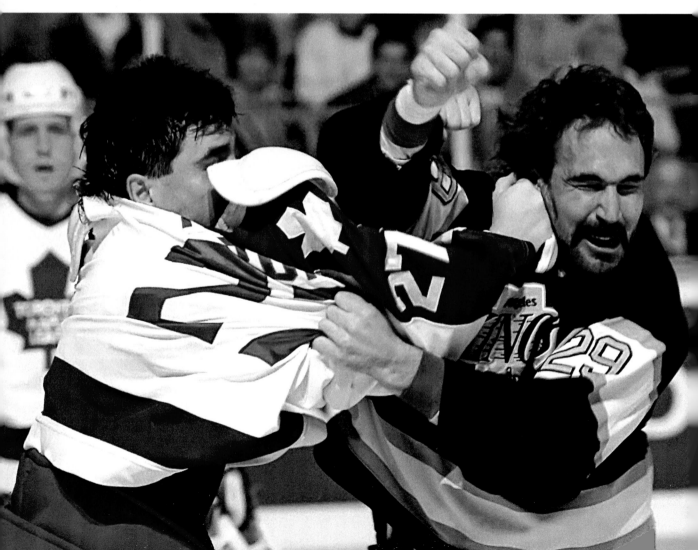

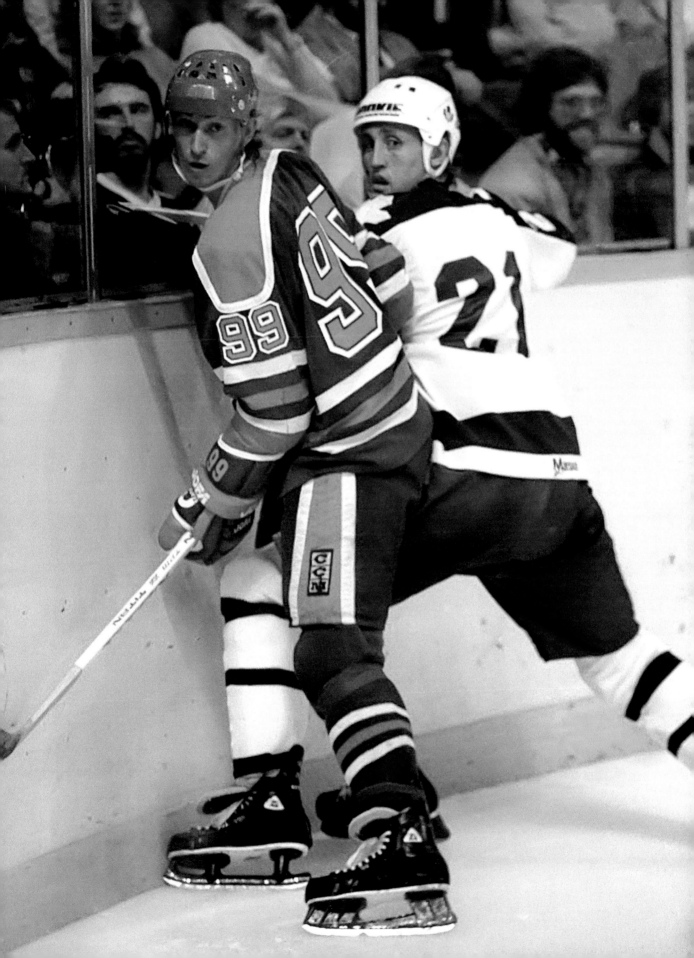

Some guys just have a face that's easy to shoot, sharp features that are easy to focus on. Börje Salming was that perfect subject; Miroslav Fryčer, too.

Then you had pudgy-faced guys, such as Peter Ihnačák. Now everyone has a visor so it's much tougher to get good close-ups. But Börje was not only a great picture, he was a great skater and a great player. I took this picture right after his terrible incident when a skate cut his face for 200 stitches. He put on a visor shortly after.

enjoyed watching The Tiger as a fan and dealing with him when I joined the Leafs. Tiger Williams was every bit as wild as his nickname.

He usually played on a line with Darryl Sittler and Lanny McDonald. They scored and Tiger did the rest.

Everybody was saddened when Tiger was shipped to Vancouver after a dispute with management. In his return to the Gardens in this picture, he scored a big goal and started riding his stick down the ice, directly at the bunker where his good friend Harold Ballard was. It was something little kids do, but the whole building was cheering him. That was Tiger's appeal.

He would call me once in a while after moving to the West Coast to order more photos of that stick-riding act, which he swore he would never repeat. We still talk when he comes through town. But he's like a lot of players after they're done. They want to talk about anything *but* hockey.

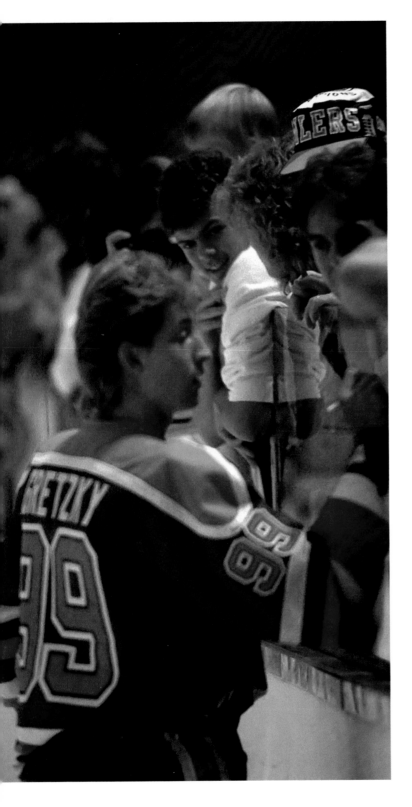

'm highlighting these pictures for two reasons. One, to underline Gretzky's popularity, especially the excitement in his first few games at the Gardens. It was a place where he always played well in front of his family.

Secondly, it's to remind people how low the glass used to be. Not so much a problem for fans during the pre-game warm-up—because you could hang right over it to get autographs. (That was also a handy time for us to be shooting hockey card pictures because helmets were off.) But the low shelf was a safety hazard, as I found out one night when No. 99 and the Oilers came to town.

All the photogs went out early to shoot Gretzky in warm-up because he was such a big deal. This particular evening, I was in a nice white shirt and the jacket that we wore at the time. I was focused on Gretzky, but not on one of the other Oilers who was firing pucks high to test the bounces off the glass.

With no safety netting at the time, a hot puck cleared

the rim and caught me right between the eyes. There was blood gushing everywhere and I couldn't see. The other guys led me to the Gardens clinic, while I could hear some kid who'd picked up the puck shouting about his great souvenir. And who is sitting in the clinic but Harold, who often hung out there before the game. He growled, "How in hell did ya get hurt? The game ain't started."

I couldn't tell him I was getting pictures of the other team, so I just said it was an accident. He offered to have one of his boys run me to the

hospital, but I just wanted to get patched up and get out of there, back to my post. I was still so dizzy that I forgot about the big bandage around my eye; when I pulled the camera up too quickly, I nearly knocked myself out again. I was hit by a few pucks at the Gardens over the years, but nothing like that night.

Pucks were always going hard and fast into the seats or breaking a pane and showering people. The wife of a guy sitting right in front of my position—a season ticket holder I got to know well—was once hit by a puck pretty bad. The players could tell it was serious, too, and they were tossing towels up to her and the paramedics. Another couple I knew sat three or four seats behind the Leafs bench. She was a flight attendant, got one right in the head and missed six months of work.

The worst part of that was Harold billed them for the ambulance. Her husband was mad enough to sue, but there are disclaimers on the tickets about the risks you take at a game. There was also the night a puck whizzed toward where my mom and sister were watching from our family's season seats, first-row reds above Ballard's bunker. It missed them, but hit the guy right behind my mom and ricocheted off the guy next to him. All my sister did was complain about their blood getting all over her coat. Below is a photo of my wife, Jane, and daughter Katie in our season seats.

Only once was I hit by a puck at the Gardens, sitting in the lower golds that served as the Marlies' game day press box.

I didn't see it coming, but Bill Walker of the *Toronto Star* sure did, dousing me with his full cup of hot chocolate as he dodged and I was struck on the shoulder. I was hurting more from the scalding cocoa on my head than the puck, but someone saw the dark brown splotch and shouted, "He's bleeding!"

To add insult to injury, Walker reached under the seat, collected the puck and flipped it to a little kid. The fans applauded Bill's magnanimous gesture, while I writhed in pain. –L.H.

This is trainer Chris Broadhurst, outside the newly rebuilt medical room in November 1989. Chris worked there for many years and helped players such as Al Iafrate with his knee and Wendel Clark through his many back problems.

n a contact sport made all the more risky by high-speed pucks, it pays to have a doctor in the house. Or three or four.

When the Gardens closed, Darrell Ogilvie-Harris was proud of the work he and colleagues Leith Douglas, Michael Clarfield and dentist Ernie Lewis had done through the years.

Ogilvie-Harris and the team had a few tense moments, such as when defenceman Mathieu Schneider got a high stick in the face and was brought dazed and bleeding into the medical room. The injury occurred in the second period, but by the start of the third, the doctors had brought him to Wellesley Hospital and back to score the winning goal.

"He had the bruised eye, lacerated eyelid, the whole thing," Ogilvie-Harris recalled in a 1999 interview. "We stitched him up [at the Gardens] and got everything arranged at the hospital to have him checked and made it back in time. It was quite an accomplishment."

One of the most gruesome injuries was Mike Foligno's broken leg the day

before Christmas Eve in 1992. When Foligno was wheeled into the medical room, the bone was sticking through his hockey sock.

Nik Borschevsky's ruptured spleen in 1993 almost resulted in the death of the plucky little Siberian.

"I was in the Gardens clinic, grabbed a phone and paged a general surgeon I knew, Ray Matthews," Ogilvie-Harris recalled of that night. "I thought he was at dinner, but when he answered, it was strange because I could hear the same noise in the phone receiver as I heard in my other ear. I said, 'Where are you?' And he replied, 'In the reds at the Leafs game.'"

Matthews quickly joined the other doctors in the clinic and they all transported Borschevsky to the hospital, where his spleen was removed.

It used to be that two to six patrons were struck by pucks during a game until the glass was raised a few inches in the 1990s. The victims included the wife of a doctor, who needed $5,000 worth of dental surgery.

Former coach Pat Burns was hit once, as was trainer Brent Smith, who was usually the first one to throw a towel into the crowd when a fan was cut by flying rubber. −L.H.

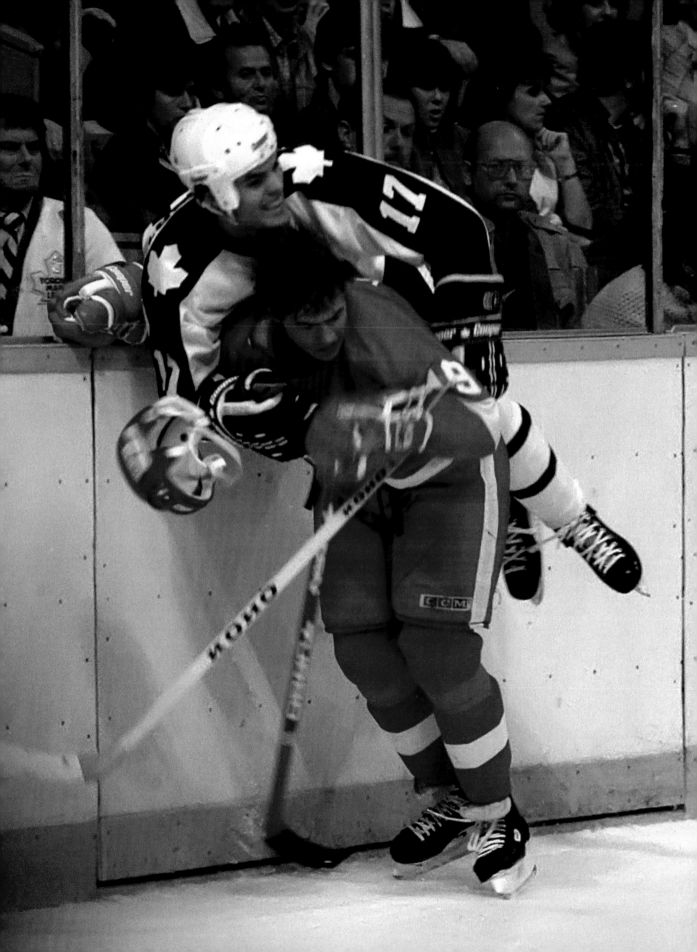

Y ou used to be able to go downstairs when a player was hurt, check with the doctor and even talk to the injured guy, on crutches or in a cast, if you wanted.

I remember Todd Gill had bad back spasms one night and was taken via stretcher right out the west end corridor past the fans. We chatted all the way to the doors of the ambulance as he filled me in on details.

Now there's total paranoia about releasing injury data, even though the injury happens right in front of a million viewers. Many teams won't say a word, even when it's clear the player isn't coming back in the game. Being so vague only leads to more confusion and media inaccuracies. —L.H.

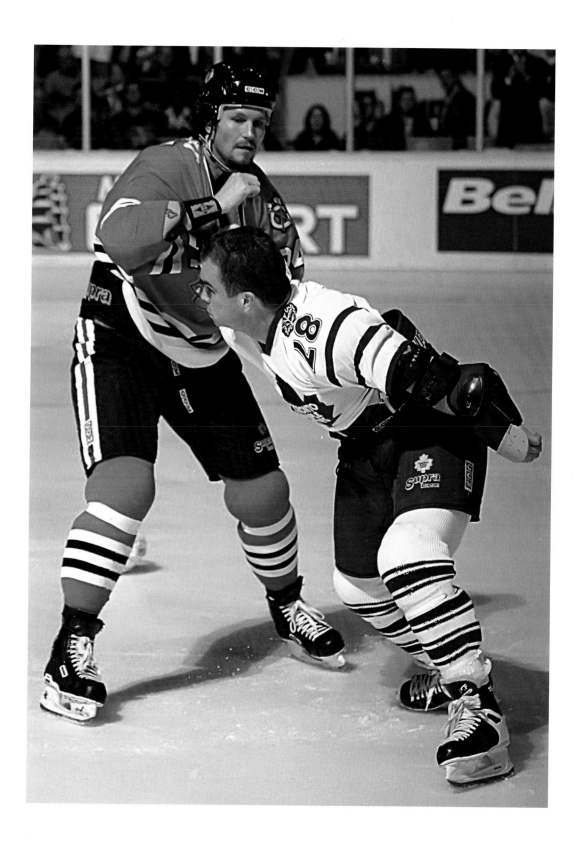

couldn't believe it when I recently looked at this print and saw who was fighting. Gary Leeman and Denis Savard? Give me a break. I don't think either one actually threw a punch.

Michel "Bunny" Larocque joined the Leafs in March of the '80-81 season, long enough to have "Toronto" engraved on the Vezina he'd earned earlier in the season with Montreal. He's the last Leafs goalie to date with his name on a major goalie trophy. He played 74 games during parts of three seasons, but, sadly, after retirement, he died of brain cancer at age 40.

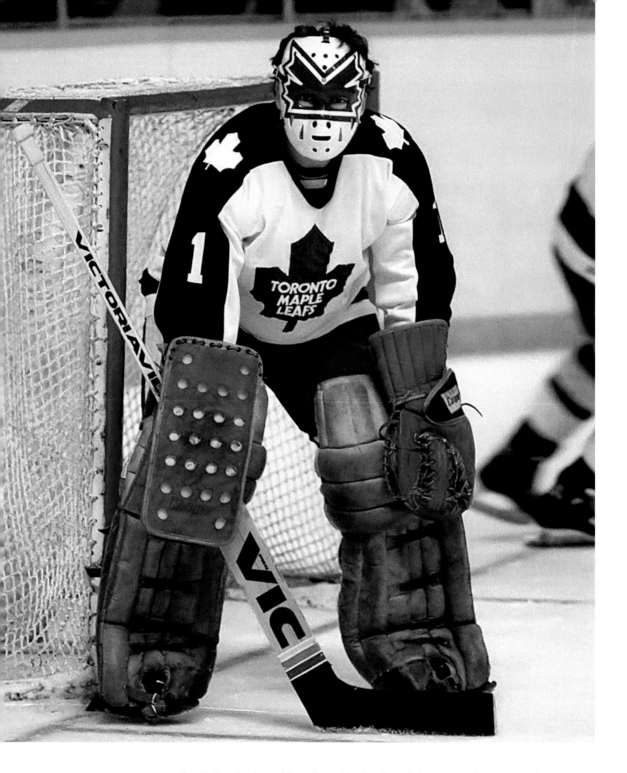

Jim Rutherford would go from the Leafs net to a rewarding career in management and eventually led the Carolina Hurricanes to a Stanley Cup.

Peter Ing was often unlucky in net, but thrived in the casino management business in Las Vegas and Niagara Falls after his playing days.

Jiri Crha, who arrived in Toronto in February 1980 from Czechoslovakia, was projected to replace Mike Palmateer as starter. But he was no Dominik Hasek and only played a couple of years before becoming a player agent.

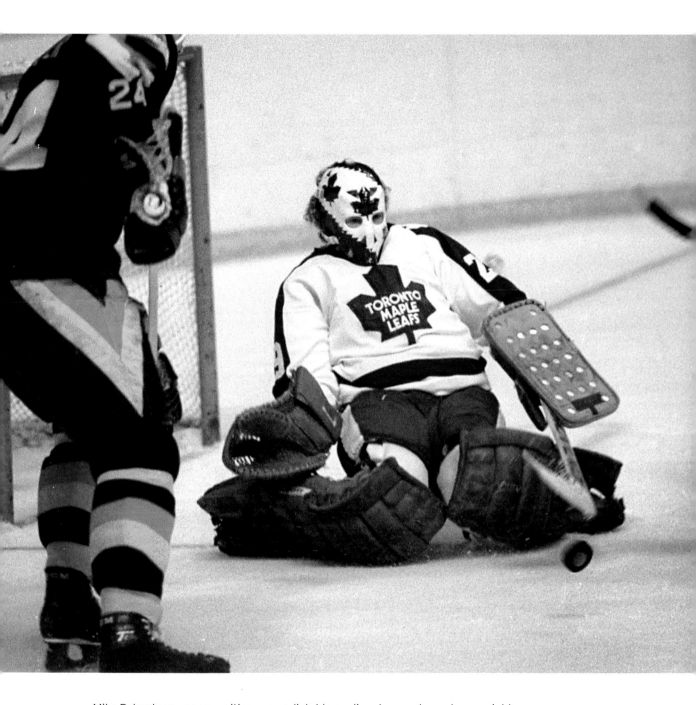

Mike Palmateer was an exciting, unpredictable goalie, whose only weakness might have been for Gardens popcorn, which he was famous for gobbling while playing with the junior Marlies. He was the playoff hero in 1978 when the Leafs upset the Islanders. Though he came back for a second stint with the team after a trade to Washington, he never recaptured his old magic. –L.H.

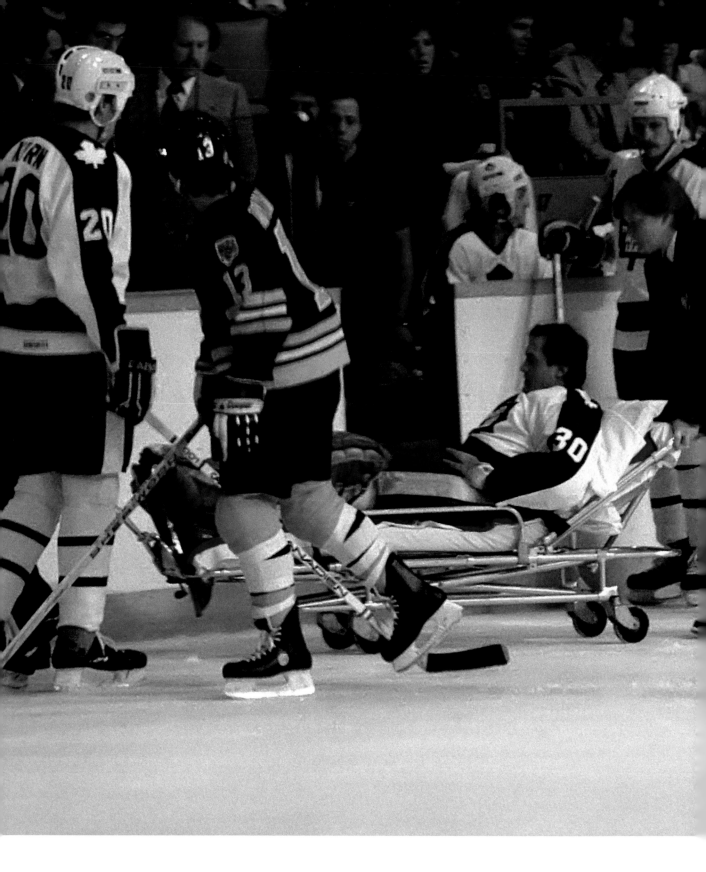

On January 9, 1985, during Toronto's 5–3 loss to Boston, goalie Rick St. Croix pulled a muscle in his lower body and could hardly move.

Paramedics came out and loaded him onto a stretcher.

At centre ice between the benches there was a wide gate on the boards that would open at the bottom. Unfortunately you couldn't remove the glass very easily. They were actually going to try shoving Rick through that low opening and under the glass but his stretcher was in the upright position and he would have whacked his head on the glass.

Several people eventually shared a brain and the pane was removed so Rick could go through safely. He survived to become the Leafs goalie coach in 2012–13.

Pictured here is the last visit of Gordie Howe as an NHLer to the Gardens, on February 16, 1980, with Hartford. He's watching his son Mark, now also a Hall of Famer, get hooked by Dave Burrows of the Leafs. To have them in the same frame was neat.

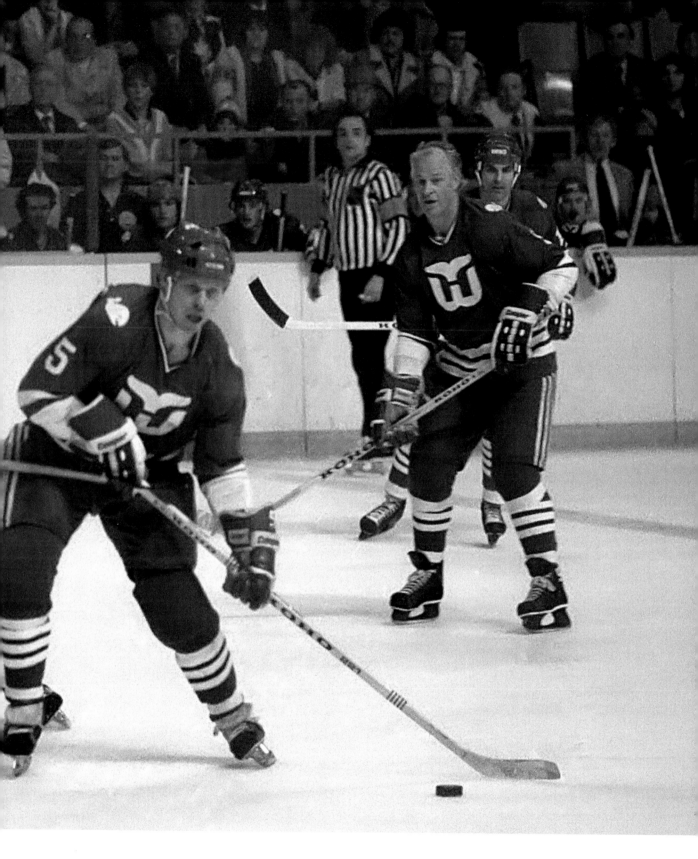

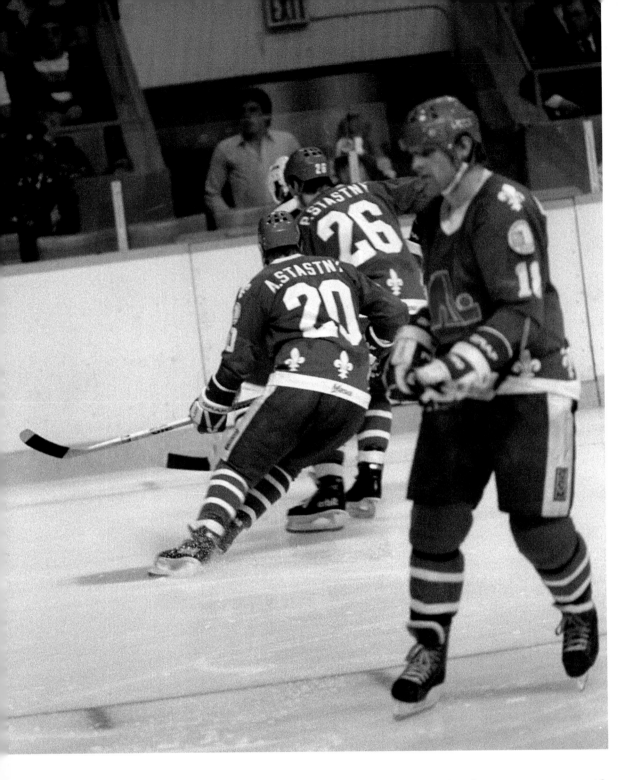

Around the same time, the three Stastny brothers came to town with the Nordiques. Marian is in the middle of the frame as Anton and Peter peel off.

on Cherry was in the Gardens many Saturday nights and was always the centre of attention.

Here he is with 1970s Leafs Mike Palmateer and Dan Maloney during the Gardens closing ceremonies and with Steve Stavro and Al Stewart. Al was Steve's public relations man at his Knob Hill Farms stores and must have been in every picture I took of Steve.

M ore than 30 years after this bizarre moment—when a fan bared all at the Gardens—I have a confession to make. Though it was taken with my camera, this isn't my picture.

I was treating two of the Kodak sales reps, Ted Footitt and Ron Clark, who dealt with Chas Abel, to this Leafs game against the Blues. We had dinner in the Hot Stove and they came back between periods for a drink—all of us having a very good time.

Ted was bugging me all night to let him shoot some game action. Since we were all having fun, and I was having a quick beer, I said go ahead and gave him my camera. I finished the rest of my drink and told him I'd be back out to my station in five minutes.

Ted knew all the newspaper guys well and he was no amateur behind the lens. He had taken wonderful photos of nature and landscapes, places like Niagara Falls and Jasper Park, for Kodak in his travels across Canada.

He got more natural subject matter than he bargained for when this streaker appeared and began prancing across the ice in nothing but his socks. Ted came running back into the Hot Stove telling me, "You aren't gonna believe what just happened!"

The next day, the newspapers went with a more conservative picture of the streaker, taken from behind, but Ted was the only one who got the frontal nudity.

I mentioned I had the picture to the Gardens people, careful to omit Ted's role. Before I knew it, Bill Cluff and Bob Stellick were on the phone telling me Harold wanted to order 20 5 x 7 prints.

I heard two stories why Ballard asked for so many. One, because he wanted to give them to the other NHL owners, and two, because he knew the family of the streaker (who was arrested and released) and thought they might like some "souvenirs" of the evening.

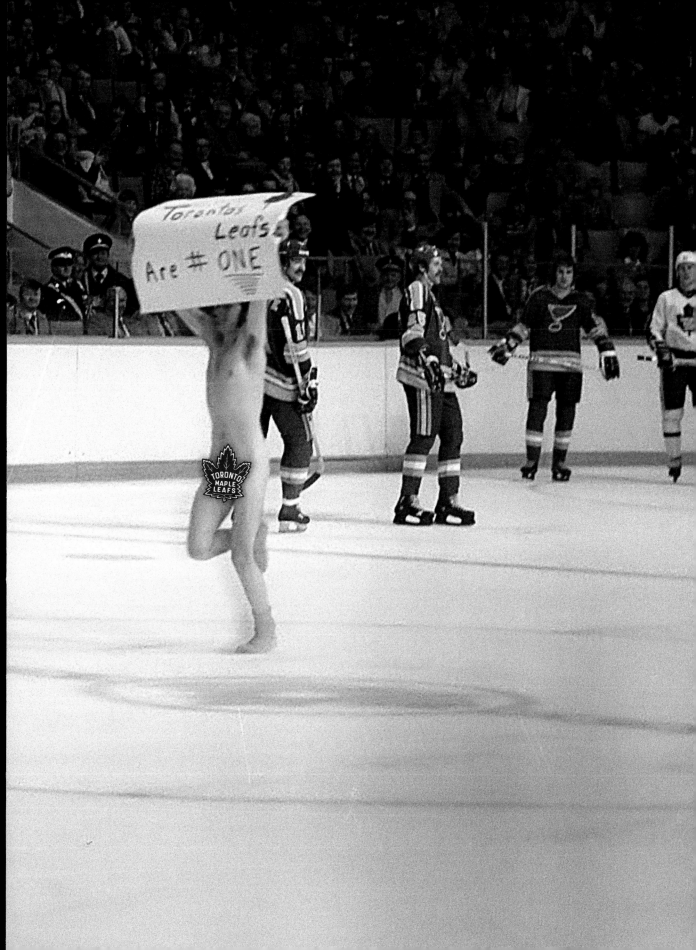

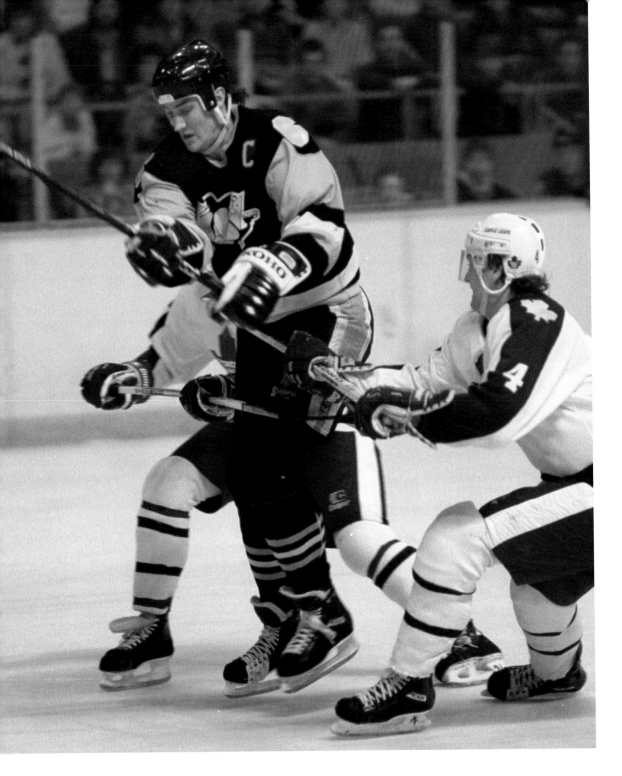

N o. 66 often complained about the cheap tactics used by far less talented players to tie him up. This picture supports Mario Lemieux's case as Rick Lanz of the Leafs tries to slow him up with a hook.

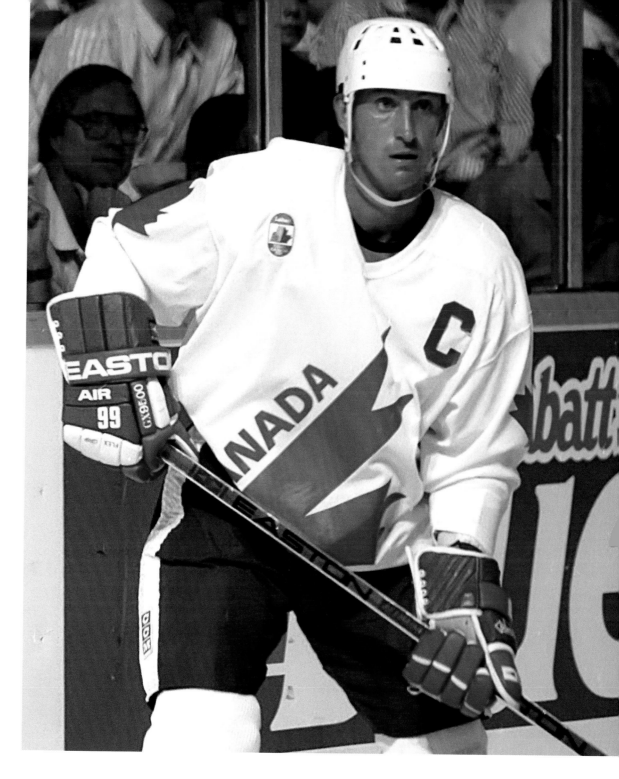

There weren't many big international tournaments at the Gardens after the first Canada Cup in 1976. The first one for me was the 1991 Cup event, which had some really high calibre hockey.

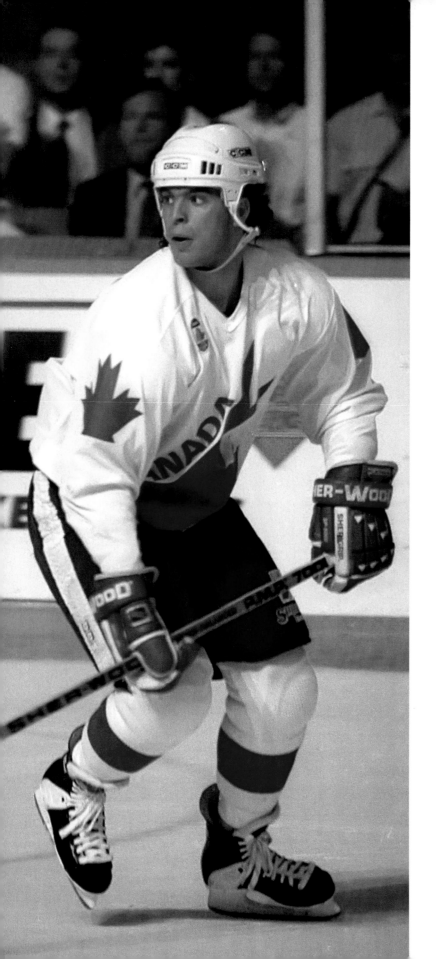

The thing I liked about the Canada Cup was that our position at rink level, as still photographers, wasn't dictated by *Hockey Night* and the CBC. They never let us go beyond a little space between the hashmarks and faceoff dots and never, ever behind the goal line.

CTV and Labatt didn't care and let us go almost all the way to centre ice, which gave us a better range of shots. The other thing I recall is how passionate fans were in these tournaments. There were no season ticket holders in their usual seats because of public sales, so the "real" fans were there in force. It made for a much better atmosphere.

The next best thing to watching Team Canada at these events was seeing the reception players such as Börje Salming received at the Gardens. To have witnessed his first games as a Leaf when I was a kid and then see him play for his country in his early 40s was remarkable. The Leafs weren't doing very well toward the end of his career and it was nice to see that old spark between the "King" and the crowd.

Mats Sundin, who is pictured here in the same tournament, once told me a great story about the '76 Canada Cup. He was a five-year-old in suburban Stockholm when the Sweden–Russia game was at the Gardens. He remembers his father calling attention to the standing ovation Salming received during that game, impressed that Canadians would think so highly of a Swede. If only he knew his son would play there 18 years later and that his number would join Salming's in the rafters of the ACC. —L.H.

These photos are from an exhibition between the Leafs and the Canadian Olympic team on its way to play in Albertville, France, in 1992. It was the first time all the Leafs who were involved in the big trade with Calgary a couple of weeks earlier played in the same game, including Kent Manderville of the Olympic team. Doug Gilmour is battling Adrien Plavsic in one photo and that's future Leaf Eric Lindros, who had not yet settled on playing in the NHL.

January 18, 1991.

There's no
turning back.

A PARAMOUNT PICTURE

intruder

t was certainly a big change when the Leafs finally started playing the
touring Russian teams in the late 1980s. Harold had been against the
idea for years.

I was actually there for the Russians' first exhibition game against a
Canadian junior team when Harold put up the famous scoreboard mes-
sage urging fans to boo because Russia had shot down the South Korean
passenger jet. I looked up at it and thought it was quite a statement to put

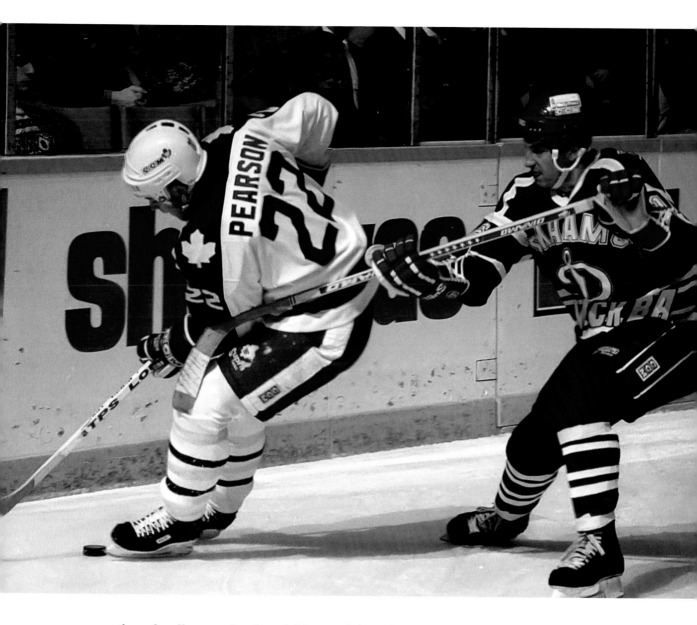

up there for all to see, but later I felt stupid that I hadn't thought to take a picture. Here was Harold essentially insulting the whole Soviet Union and I missed it—though the newspapers sure didn't.

It was interesting to see touring clubs such as Moscow Dynamo finally play at the Gardens, but in the end, they were just another team the Leafs couldn't beat. I think they lost both games to Dynamo.

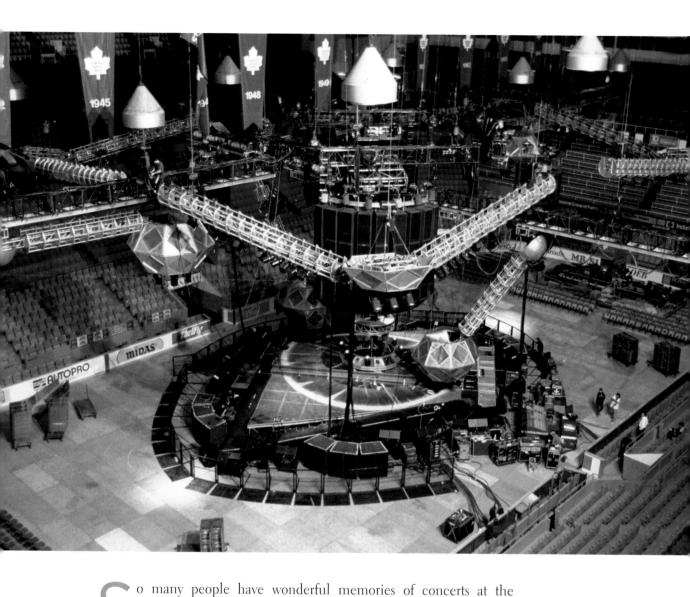

So many people have wonderful memories of concerts at the Gardens, but a lot of mine are only three songs long.

That's how much time most photographers are given at the start of a show before security gives us the boot. At the Gardens, we were kept off to a room at the side before the show began and then ushered in to take some quick pictures. We could only stay two or three songs so we wouldn't be a distraction. You learned to live with this, except that the first few songs are usually mood numbers with lots of dark red and blue lights. So it was very dim and not great for shooting until the brighter lights would come on. And the star or stars would not always come on stage for the first number.

You stood between the stage and the first row of seats and, despite the short time frame, it was pretty cool to be that close for bands such as Queen and ZZ Top.

Sometimes the musicians looked right at the camera, as Mike Love of the Beach Boys did for me in 1980 (p. 161). My wife and I actually had tickets for this concert from a friend at CBS Records, so I joined her later and we capped off the night in the Hot Stove. Who should come in for drinks afterward but the band members themselves.

I was positioned a little further back to shoot The Who in one of their "Farewell" concerts in 1982. That brought things full circle for me: I'd seen The Who as a 16-year-old kid at Kingston's hockey arena for five dollars and you could sit or stand wherever you wanted.

I did get a laugh recently when my son, Dave, took some photos of Pete Townsend and his new book for a story in the *Sun*. He told Townsend

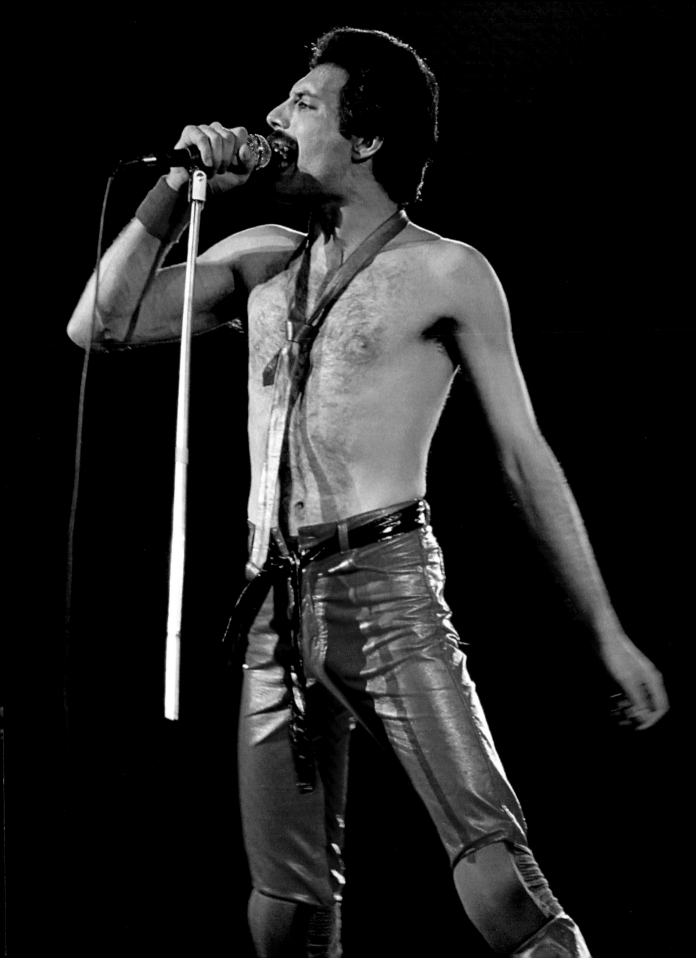

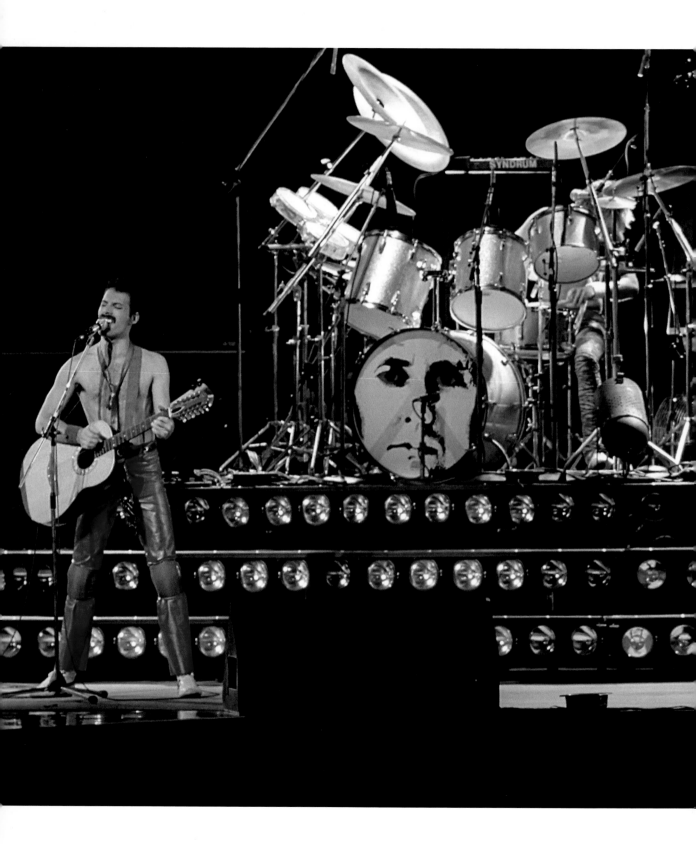

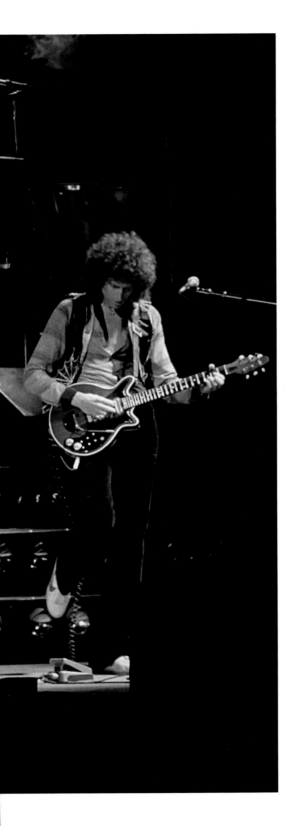

about his dad shooting The Who 30 years earlier, which caused both of them to pause and think about how long ago that was.

The Gardens certainly looked different for concerts with the big stage, sound systems and seating for 2,000 people on the floor. The place could hold 18,000 for concerts, so the building could get incredibly hot in the summer months with that many extra people and no air conditioning—something that didn't matter during winter Leafs games.

The one drawback for Chas Abel was that we operated one of those little drop-off photo kiosks across the street from the Gardens called Snap Shops. People would come out after the concerts, either drunk, high or whatever, and smash the windows of our booth. The police would call me late at night and I'd have to drive all the way in from Streetsville to do the repair work, as they wouldn't leave the scene until someone showed up. The vandalism got to be so frequent that I had plywood cut and measured and ready in the garage for whenever the police called.

But the concert business did

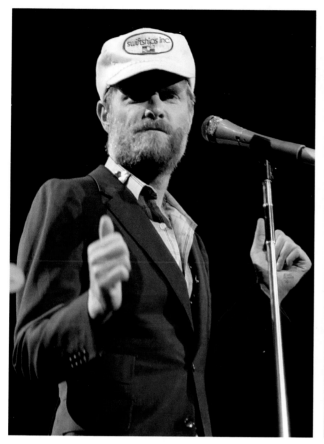

provide me one of the biggest perks of the job when I first began at the Gardens.

I had a buddy who worked for CHUM-FM and Concert Productions International and he mentioned I could get in to the Gardens to shoot anything special that he wanted. The plan was we'd get big 11 x 14 posters of the acts that he might be able to sell through his office. In just one summer, I shot Queen, the Beach Boys, The Who, ZZ Top and ABBA. But I didn't quite understand copyright law very well at the time. Lawyers frown on selling photos without artists' permission, so that was it for my concert career. I think our poster plan went no further than having them hung up in the offices of the radio station.

No matter which type of music you liked, people agreed there were two things that made Gardens concerts unique.

One was "the scene" of teens hanging out in the hallways and washrooms, often just seeing bits of the concert. The other was the crumby Gardens sound system, a losing battle for musicians and any public speakers going back to Winston Churchill in 1932.

The more people attending such events, the less the sound system came into play.

"You were usually okay until you got into the greens and the high grays," said Bob Thompson, who reviewed many rock concerts there in the 1980s and '90s for the *Sun*. "Then you'd lose the lower end of the bass and drums." —L.H.

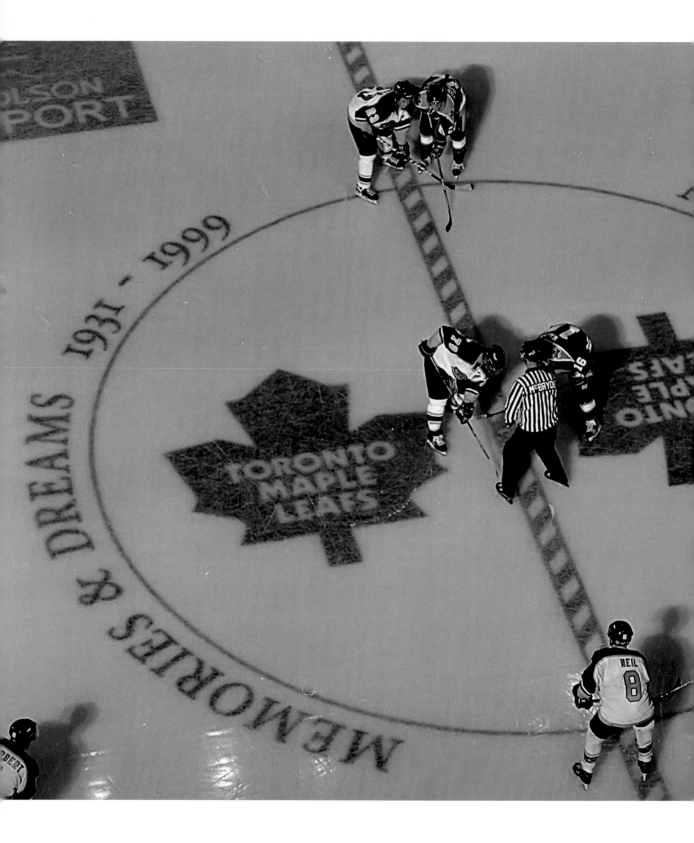

I loved watching the Marlies because I was a member of their booster club when I was a kid. You could get season tickets for about 50 cents a game if you went to the CNE in early September and picked up the coupons at the Better Living Centre.

My dad would take us kids to the Marlies game, drop us off and not have to worry about us for two or three hours. We were having fun, though we sometimes hardly watched the games. We just liked running around the Gardens. I'll always love the old Marlborough "AC" crest.

They moved the Marlies to Hamilton in 1989, but it was great to see the St. Michael's Majors come back to Toronto and play up to the year the Gardens closed. This is a shot of Mike Zigomanis against St. Mike's while he played for Kingston. The irony is Mike eventually played for the American Hockey League Marlies at Ricoh Coliseum.

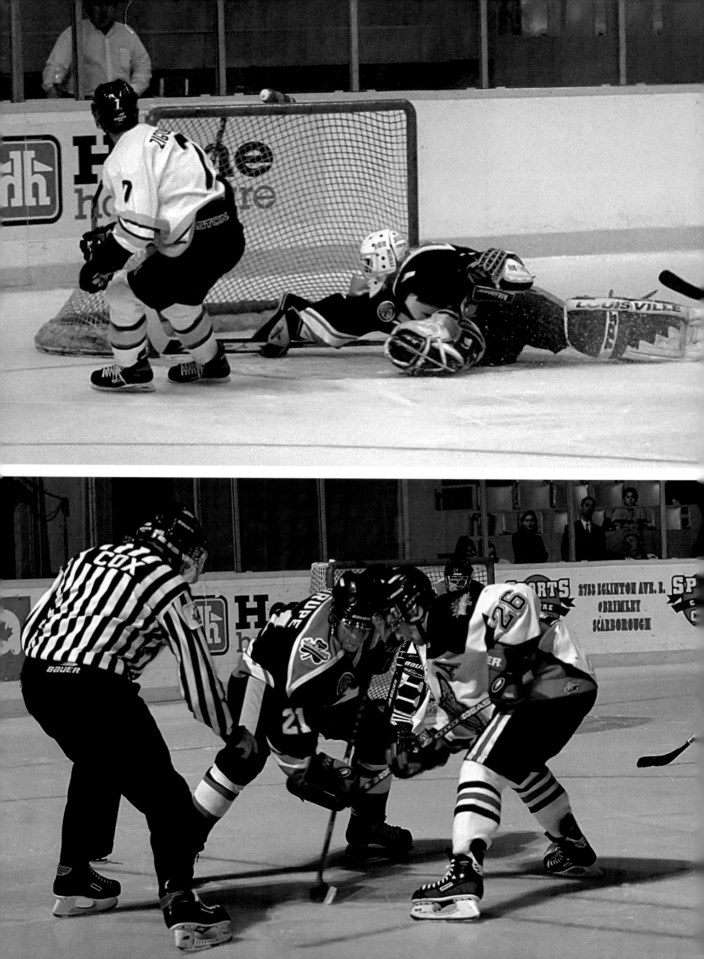

probably liked working with the lacrosse people more than anyone.

I loved the Toronto Rock players, all of whom were so polite and approachable. They didn't think they were anything special, just teachers, salesmen or office workers who happened to be good enough to play pro lacrosse. They didn't make a ton of dough doing it, either. And the fans were nuts, far more passionate than they are for the Leafs.

They were so much fun to be around that one year I paid my own way to Everett, Washington, to shoot the final against the Washington Stealth. Almost every Rock player came up to shake my hand and thank me for

coming. One year, they won the title on a goal in the last second. It was fun to shoot the celebrations in the dressing room, which I'm still waiting to do with the Leafs.

I remember the first time the Rock had a championship game at the Gardens it was an extremely hot night in May. It had to be 25 degrees Celsius outside and naturally very warm indoors. I think Bill Watters, the team president, said they broke some kind of record for the most beer sold at the Gardens that night, about 75,000 cups. My wife, a wine drinker, was at the game but when she went to get her second drink they were sold out of wine, too.

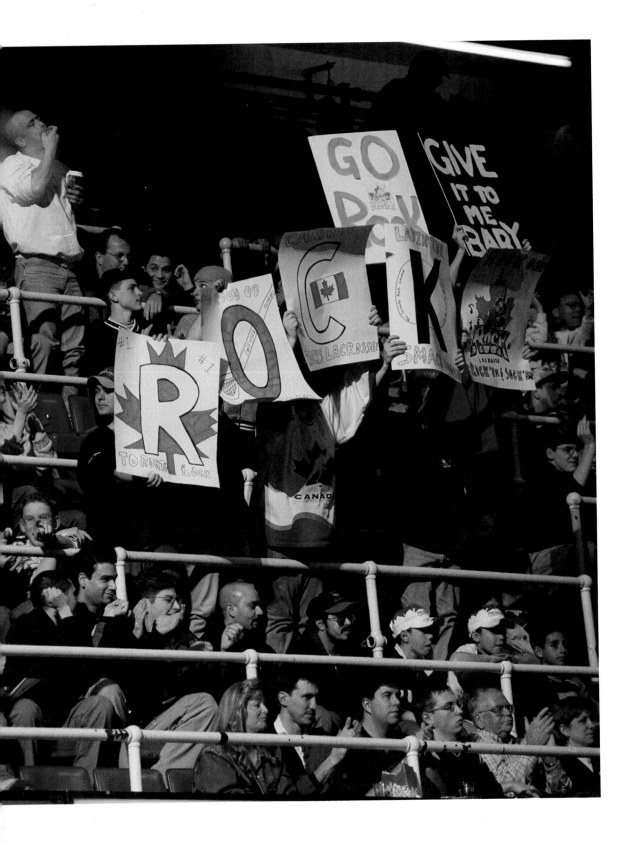

I have to say lacrosse is a very difficult sport to shoot. With hockey, when the puck is on the ice, there's a frame of reference. But in lacrosse you have no idea where the ball is going to bounce. And I have no idea how they can score on those little nets against goalies with such huge equipment.

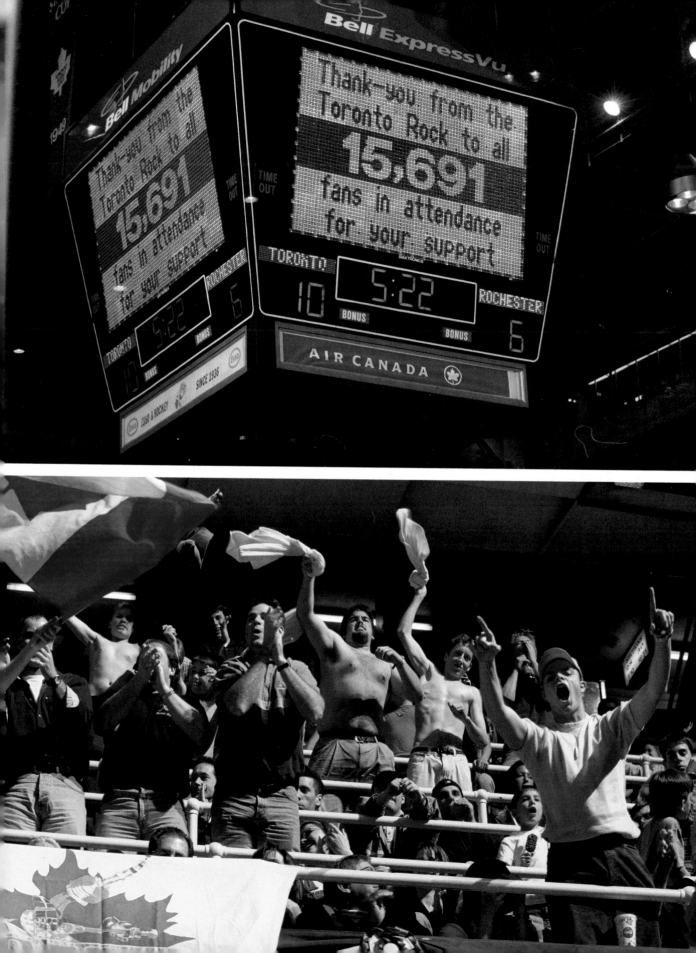

SEC. ROW SEAT
31 A 2
NORTH

Retain Stub — Good Only

(33)

WED. FEB.14

7:30 P.M.

1990

Davis Printing Limited

HARTFORD WHALERS
VS.
TORONTO MAPLE LEAFS

ADMIT ONE. Entrance by Main Door or by Church Street Door.

Maple Leaf Gardens
LIMITED
CONDITION OF SALE

Upon refunding the purchase price the management may remove from the premises any person who has obtained admission by this ticket.

31 A 2

NATIONAL HOCKEY LEAGUE
PRICE 25.00 + RST 2.50 = $27.50

WED., FEB. 14, 1990

I saved this particular red ticket as a reminder how great that whole Valentine's Day was in 1990. My wife and I found out our offer on a new house had been accepted, we spent part of the day watching tennis at the SkyDome and made it over in time to watch the Leafs and Hartford (a 6–6 tie with a disallowed overtime goal by Toronto).

Everybody tells me I have best job in the world, shooting and watching every Leafs game from ice level.

But if you just watch the game then you miss the photo! I usually watch sportscasts at home after a game to see how the goals were scored and what hits were made. My perspective of the Leafs is not quite what everyone imagines. Before the digital age, I had no idea if I had the great shot until my film was developed. Now I can look at the back of my camera and see right away if I have the desired picture.

Through Chas Abel, I had access to the latest and greatest cameras and film that came on the market. In addition to photofinishing, we were a distributor of cameras, film and related products to retailers and major chains across Canada.

I came upon Olympus equipment, which we had through a dealership, and began using their lenses exclusively. I believe that Olympus had the best optics in the market and it showed on the sharpness of my photos. We'd shoot at 250th of a second at 2.8 f-stop with 400 ISO film.

My favourite lens at the time was a 180mm f-2, really sharp and perfect for ice-level photos.

When autofocus cameras came out, I tested one in the office and around our building and it seemed to do a pretty good job. So off I went to the Leafs game and started shooting. The focus mechanism itself was pretty slow, but it was kind of neat not to have to adjust lenses anymore, to just point and shoot. Then I noticed that the autofocus had a hard time locking onto a

white background, a big problem because Leafs home sweaters are white. But that turned out to be the least of my problems that night.

Security came over and said Mr. Ballard wanted to know which idiot was using a red light beam and to shut it off immediately. I looked around at the other guys and we all shrugged. The guard left, we kept shooting, but he was back in just a few minutes, saying Harold was really upset that the beam was still visible and distracting him. I thought it must be someone in the crowd behind me. When play stopped, I looked at my new camera again and realized it did emit an infrared beam when trying to focus in low light. I quickly grabbed my old camera and finished the game.

I had Olympus cameras right up until I put my strobe lights in the Gardens in 1992. But they would only synchronize with a flash at 160th of a second, which was way too slow to shoot action sports. I had to switch to Nikon, which I still use.

Tennis was about the easiest sport to shoot at the Gardens. Just stay in one end and focus on one person because you know the ball is coming to them.

It was fun to watch the great players of the day: Jimmy Connors, Ilie Nastase, Björn Borg and John McEnroe, who was, of course, yelling at people all the time. A fellow photog sitting next to me found out in a close encounter just how loud McEnroe could be.

The guy needed more film during a McEnroe match and started ripping into a 20-roll pack that was covered in cellophane. Naturally, the noise was distracting and when he looked up, McEnroe was standing over him, shouting his head off. The whole Gardens was staring at us as McEnroe berated the guy for disturbing his concentration.

One year, Ballard was too cheap to take the glass out of the rink, so these people in the lower rows had to watch the matches through the window.

W omen's gymnastics is about as far from hockey as you can get. But the Gardens asked me to cover the 1980 World Cup, just to have something of it on record.

I'd never shot gymnastics, but I began moving from event to event and took a few frames of this young lady on the balance beam. I thought it made a nice, clean print and I later hung it on my office wall to add to my portfolio of sports photos. Looking at it closely one day, I realized why this girl held the beam so well. Something to do with her six toes.

The Gardens was the site of the first NBA game in 1946 and before closing, it would see many visits by the Harlem Globetrotters, the Buffalo Braves and it was even briefly the home of the Toronto Raptors. In this picture, it's being prepped for the World Cup of basketball in the early 1990s.

There were a lot of celebrities in the building for the last game. I like this photo because Hilary Weston, then Ontario's lieutenant governor, was there with Premier Mike Harris and Steve Stavro. The row of Canadian VIPs meant that the new NHL president, Gary Bettman, was bumped to another row. Hilary seemed to be enjoying having her picture taken at such a special event.

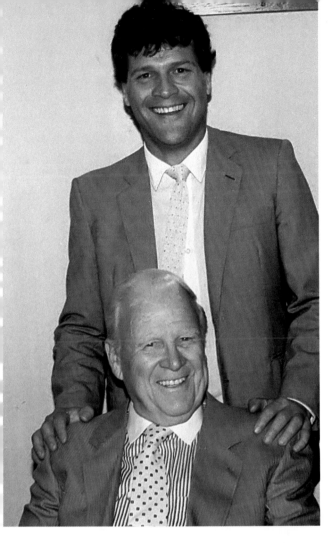

Now this was a very rare moment, during a lull in the public battles between Harold's companion Yolanda MacMillan and his son Bill.

Yolanda was quite a presence at the Gardens. I would phone the hockey office looking for one of the secretaries, but Yolanda would pick up in a very pleasant tone and say, "Harold Ballard's office, who is calling please?"

Wayne Gretzky's pretty wife Janet, an actress, came to watch him play at the Gardens in the 1991 Canada Cup. This was the best I could do trying to shoot through the glass. Of course, their daughter Paulina is much more famous for being photographed these days.

The Ice Capades was the kind of family event I would take my gang to and then go shoot the show.

It wasn't easy, because there was only a spotlight on the skater and most of the time it was not enough light to shoot. I remember Josée Chouinard was a member of the cast for one show. She was the top Canadian skater at the time, very good looking and a star in the show. She came straight out for her portion of the show and immediately fell. Not even making a jump or a turn, but going in a straight line.

She could've made a lot of money, I thought, being the top Canadian and that attractive . . . if only she could skate.

I didn't usually shoot wrestling, because it was the same deal as concerts—you're not allowed to sell anything you shoot afterward. But I heard one lucky hockey guy from Getty Images wound up as the WWF's official photographer and went everywhere on tour with them.

I certainly knew how popular wrestling was in the Gardens, going back to when the building first opened.

Don Giffin, who was the Gardens chairman after Mr. Ballard, requested a picture of Hulk Hogan for his nephew, so this is one bout I did attend. I happened to be in the hallway when Hogan came out of his dressing room, and I got the picture Giffin wanted. I stayed to watch Hogan in the ring. He was fighting a guy in an army suit, maybe it was Sgt. Slaughter. That was a pretty vivid memory, especially getting a picture with him ripping his shirt off.

When I was young, my friends and I were fascinated by wrestling at the Gardens, both televised and live, when I could afford my first ticket.

A pal of mine knew the famous Lord Athol Layton, but what really transfixed me was the female wrestlers such as the Fabulous Moolah. Of course, we also loved Bobo Brazil, Tiger Jeet Singh and Haystacks Calhoun and screamed obscenities at the Sheik. But I had a soft spot for the heels, such as Pampero Firpo, Sweet Daddy Siki and those hippy hooligans from Hamilton, the Love Brothers.

There was a legendary Gardens story of an elderly woman who always sat above one of the portals and whacked villainous grapplers with her umbrella as they entered and exited. But crowd interaction could get a lot worse.

In the 1950s, when the hated Killer Kowalski won an unpopular decision, an embittered fan, who was half his size, leapt to the runway and punched him. The guy ran out of the building; Kowalski, wearing only his wrestling trunks and boots, chased him out the northwest exit and down Wood Street. —L.H.

In September 1984, I brought my son, Dave, down for an exhibition game against the Cup champion Oilers. I saw Mark Messier, who was not playing that night, sitting alone in the golds. I sent Dave over for an autograph and was quite surprised by the smile on Messier's face as he took the time to sign and have a chat with Dave about hockey.

David expressed interest in being a photographer and shooting Leafs games like his dad. It made me quite proud. So I brought him along on one of those Take Your Kid to Work days. Unfortunately, there was no game that particular day, so we wandered up to the Gardens, watched the Leafs practice and went to the Hot Stove for lunch. But he still wanted to get into the business some day.

We started going up to Newmarket on Friday nights where the Leafs' farm team, the Saints, played home games. Dave got his feet wet shooting action there and started getting very good at it. Back when I started at the Gardens, Dave was just a few months old but he joined me full time shooting Leafs games in the late 1990s after studying photography at Loyalist College in Belleville.

When I thought he was ready for the NHL, I brought him down to the Gardens. One night in Dave's very early days, Edmonton was in town. He went through my collection of lenses and decided he wanted to use the big 300mm f2.8 manual

focus. It was a huge piece of equipment and I helped position him behind the rail seats for the game. He was not quite tall enough to shoot over the heads of the fans in front so he would try to shoot between them.

Everything was fine until he turned the big lens too quickly while following play and bumped the head of the person seated in front of him. Dave quickly apologized and ran down to tell me what happened.

"I hit some guy!" he said, pointing to an older fan.

Well, the "guy" happened to be Walter Gretzky, just recovering from a stroke and not yet back to 100 percent. He'd come down to see Wayne play. He was sitting with another one of his sons. It turned out Dave didn't hit him too hard, but the poor kid sure felt bad.

Dave was creative, full of energy and loved being on the team's official photography staff. But his exuberance led to more trouble during another game.

He was always looking for different places to shoot from, and one night I suggested that instead of ice level, he try for a higher angle. If you didn't mind the exercise, you could get up and shoot from behind the net or in the end-red staircases. Dave had been fascinated by a picture he'd seen that had been taken directly over a net at another NHL stadium. It was the same angle you see now on TV replays.

Off he went to get that perfect vantage. There was a small grated platform above one of the nets, near the top of the building. He managed to get up there somehow and shot the first period from this new, breathtaking location.

But the grate was covered by some musty, dusty old carpet from who-knows-when. Every time Dave moved around to shoot, small bits of carpet crumbled and fell like snow, landing right in the crease of Leafs goalie Felix Potvin.

Potvin must have complained to Pat Park, the media relations director, because Park came after me, really upset, demanding to know the identity of the mystery photographer above the goal creating the flurry of fibres. Pat had seen a person up there but, thankfully, could not make out who it was.

Naturally, I pretended not to know Dave and I buried the images he took to cover his tracks. Eventually, I think I did tell Pat that it was Dave, but I waited until he calmed down.

Dave later got a job at the *Toronto Sun* and we worked side by side.

What can you say about the loyalty of Leafs fans? I was probably the biggest one. Sure I would say bad things about the Leafs under my breath when they were losing, but I am a complete die-hard and it was so difficult to be neutral when you were watching them. I've worked in other buildings, during the 1993 playoff run, for instance, and let me assure you, there are photographers who openly cheer for their teams, even though we aren't supposed to while we're on the job.

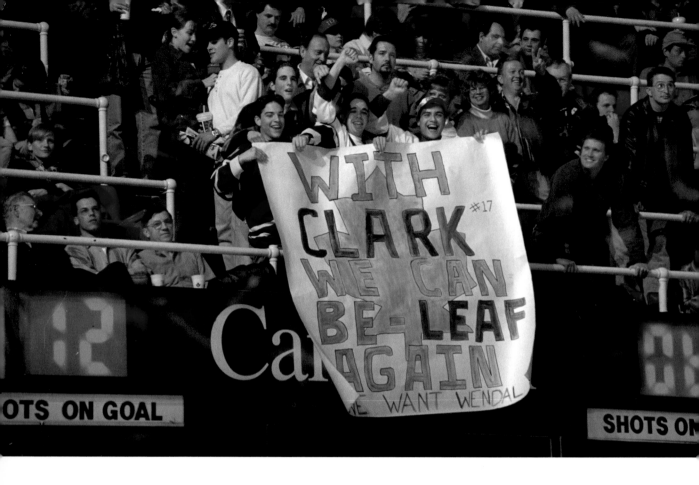

OTS ON GOAL SHOTS ON

WITH CLARK #17 WE CAN BE-LEAF AGAIN WE WANT WENDAL

The best part of taking pictures of fans for me was when they'd get all decorated in costumes and team colours. At playoff time, the corporate guys would be out of there and the "real" fans would show up.

People came in all manner of blue and white, they dressed up as the Stanley Cup, waved flags and flashed all these witty signs. They used to come early and cover the south end with homemade banners.

Of course, when the team did poorly, some people switched to wearing gas masks and paper bags.

1931-1999

MAPLE LEAF GARDENS

MEMORIES & DREAMS

1962

STANLEY CUP

TORONTO MAPLE LEAFS

1963

SUNDIN
13

TORONTO MAPLE LEAFS

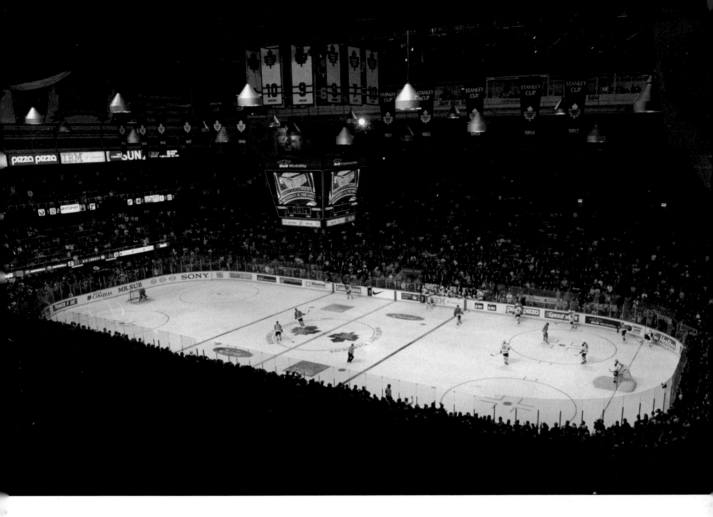

The last Leafs game at the Gardens was a long, emotional evening for me.

I worked there so long, my kids had almost grown up there. The team was leaving the only home they had known for a mysterious new one in a cookie-cutter arena. In a way, the move was scary for me.

But the game on February 13, 1999, was the closing of a chapter and our photographers were going to do it right. I had a team of four assembled: myself, Dave, Dennis Miles and Brad White. We were there right from the start of the day when they did the show rehearsal. It was a long day and the doors of the Gardens opened early in the morning so that fans could come in to buy the final program. I was quite proud that the front cover was my photograph of the Gardens at night. Fans were lined up well outside the front doors for a chance to buy this piece of Leafs history.

The Leafs alumni had gathered at a local hotel to sign hundreds of programs and memorabilia. Leafs from all decades were there to get their instructions for the post-game ceremony. Each one of us photographers

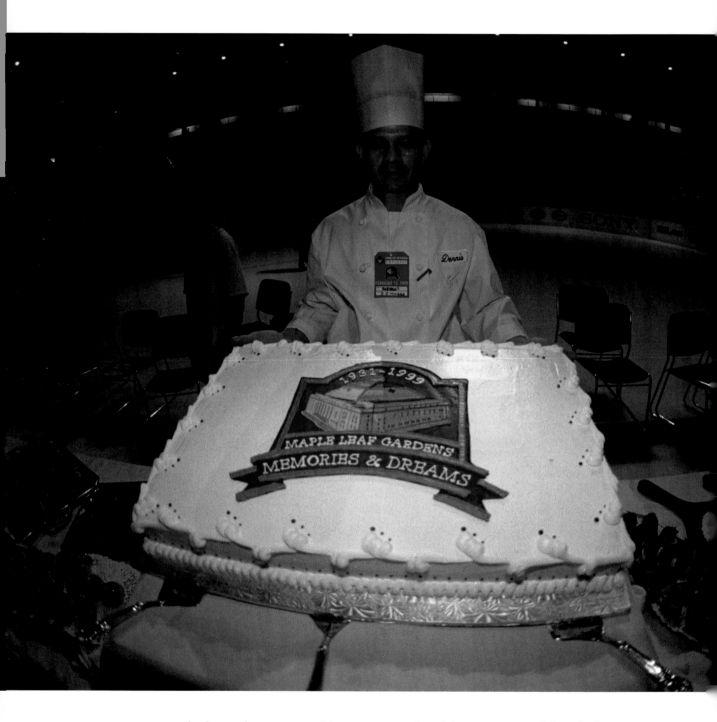

had to make sure everything was covered and that we captured the whole day in photos. We shot autograph sessions, fans, dress rehearsals and even the food for the post-ceremony party. Anything and everything that was taking place that day. We didn't leave until 1:30 a.m.

What stood out for me was my picture of Sundin accepting the Gardens flag from the oldest captain, Red Horner, to take to the ACC. You could see both of them were very moved by the ceremony. It was like a torch being passed.

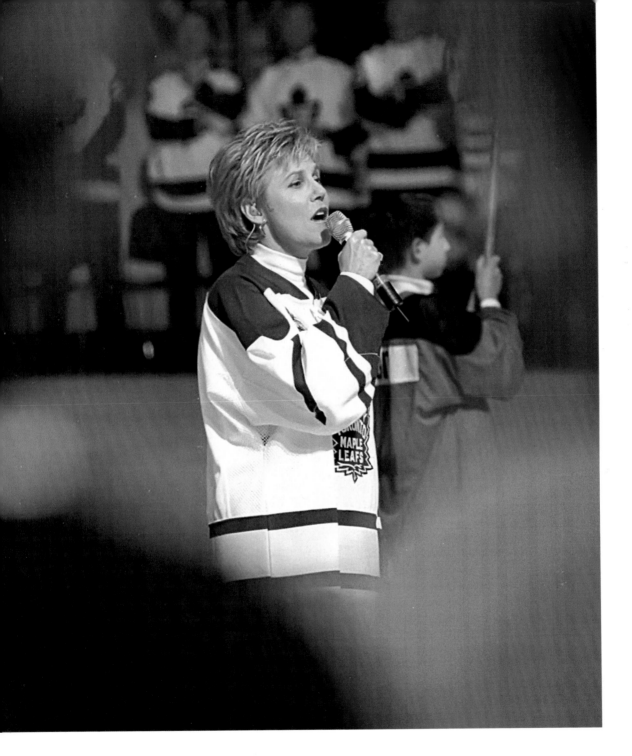

I sent Brad up to the same place where the famous first picture of the Gardens' opening ceremony was taken in 1931 to try and recreate it.

We also got a nice shot of Anne Murray singing "The Maple Leaf Forever."

But we weren't given access to the ice, which kind of pissed me off. It was all about TV people not wanting us around. So when one of their cameramen slipped and fell in front of everyone, I could almost hear my staff cheering. The game itself was a rough and tumble affair, but

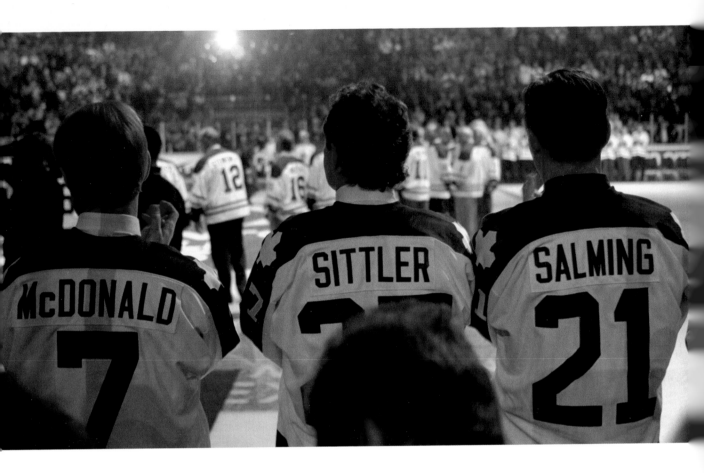

the Leafs were not able to pull out a victory. Bob Probert of the Chicago Blackhawks scored the last NHL goal in the Gardens.

It took us weeks to go through all the pictures from that night and scan them all. We'd done everything off the ice from morning until night, everything on the ice from first faceoff to last. Until researching this book, I don't think I had ever seen everything from that night.

saw so much and heard so many touching personal stories throughout the day of that last game. In the pre-internet era, it was tough to jam them all in the February 14 paper.

But it's a good thing we did, because our special pullout on the Gardens closing earned the *Toronto Sun* a place in the Associated Press Top 10 sports sections in North America that year.

Players such as Kris King recalled watching the Leafs at the Gardens in "the two-channel town of Hornepayne, Ontario" every Saturday night.

Darrell Ogilvie-Harris spoke of all the player and spectator injuries he and the team doctors patched up at the little clinic. TV producer John Shannon related how the Gardens made a *Hockey Night* broadcast "the perfect little Canadian theatre." Three generations of the Watters family were there for a last look, with Leafs exec Bill and his son Brad, who brought his 16-month-old daughter for her first and last Gardens visit.

Doug Gilmour, by then a Blackhawk, was there in a kind of kismet that made the evening perfect. The decision had already been made that Gilmour, and not Chicago captain Chris Chelios, would take the ceremonial faceoff.

I had already tracked down Harold "Mush" March, who had scored the first Gardens goal for Chicago back in 1931. He brought the puck from his bedroom dresser in Elmhurst, Illinois, where it hadn't moved for years, despite several handsome offers to purchase it.

The music that played all night covered seven decades of life in and outside the Gardens: "In the Mood," "As Time Goes By," "At the Hop," "Don't Let the Sun Go Down on Me," "Glory Days."

The game was a blur. In fact, all I remember is that Probert, of all people, scored the last NHL goal in the building for the Blackhawks. The post-game highlight was 90-year-old ex-captain Horner handing Sundin the commemorative Gardens flag.

"Take this to our new home, but always remember us," Horner said in a strong voice and Sundin, with a visible lump in his throat, began waving it to the cheers of 15,726 fans.

A giant 11-point Leafs logo was placed at centre ice and filled with player guests and long-time Gardens employees.

Eddie Shack had kicked off the show with veteran Zamboni pilot Sam DeAngelis, pulling around the Gardens' original barrel ice scraper. The seldom-seen but always-heard Paul Morris also was honoured, celebrating his 1,561st consecutive game as announcer.

"[Fans] didn't live here like I did, but they did in their dreams," an emotional Morris told the crowd. "This was like home to many Canadians."

Anne Murray, backed by the 48th Highlanders, sang a stirring version of the club's little-known official song, "The Maple Leaf Forever."

"This was terrific," coach Pat Quinn said, having donned his Leafs jersey with the rest. "I know the young guys were excited, but to see my age group and the ones I listened to on radio was really something. They are what this building is. I couldn't stop clapping."

The 1970s stars—Darryl Sittler, Lanny McDonald and Börje Salming—were in a friendly competition with Johnny Bower, Red Kelly, Frank Mahovlich and George Armstrong for loudest ovation. Chants of "Go Leafs Go" echoed between presentations, while the volume rose as fans reacted to deceased Leafs icons on the video board such as Punch Imlach, Conn Smythe and King Clancy. Teeder Kennedy sent a video message as he prepared for knee-replacement surgery and received

the old "C'mon, Teeder" cry from the crowd. Emcee Ron MacLean even sent a greeting to no-show Dave Keon.

Fans came dressed in Leafs sweaters representing all eras, and reporters were in the spirit, too. Dave Shoalts of the *Globe and Mail*, my *Sun* colleague Mike Ulmer, and I sported 1930s gangster-style outfits, wearing our press cards in the hatbands of our fedoras.

The '67 Leafs were lionized that night (it had already been 31 springs without a Cup), while players old and new came up to a dressing room podium in pre-arranged pairs for post-game interviews. The tandems included Salming and Sundin and two tough-guy quipsters, Tie Domi and Tiger Williams. The latter duo represented almost 3,000 combined penalty minutes.

"You guys should be able to play another 50 years . . . you don't do any hitting out there," Williams chided the younger, much higher-paid enforcer. "I might have kicked the shit out of you."

"I couldn't do any more damage to your face," Domi zinged in return.

But the two were united in praise of the late Ballard.

"The year I was drafted," Domi said, "Mr. Ballard called me over and said, 'Kid, you'll be all right because you have this'—he pointed to my heart—'just like Tiger Williams.'"

Williams said you could always measure a person by how he treated you. And in that regard, Ballard was a winner. "Bricks and mortar you can get anywhere, but it's the people that count," Williams said. "That's what I'll remember about the Gardens." −L.H.

This is a shot that one of my photgraphers took just before we wrapped up for the night. (You can see the clock in the background reads 12:55.) I'm looking at the big on-ice party and remembering the years I spent at MLG.

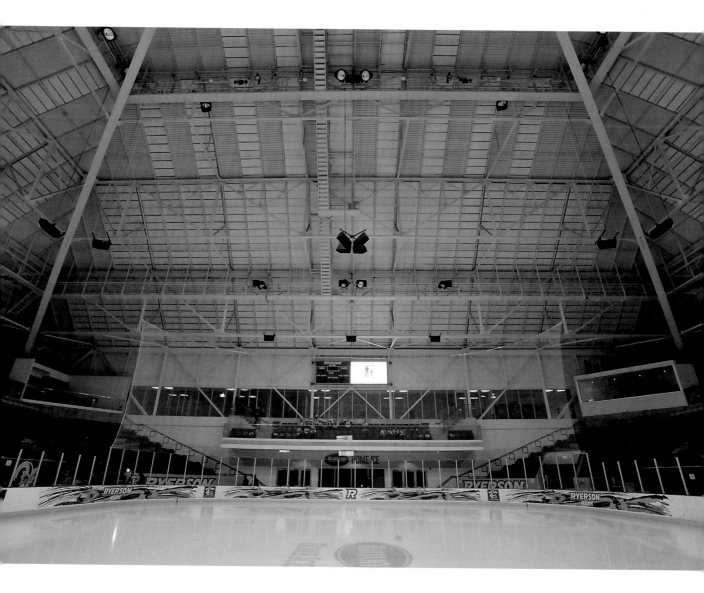

I n September 2012, hockey returned to the Gardens with the opening of the Mattamy Athletic Centre at Ryerson University.

I had not been back inside the Gardens since 1999 — not even to the corner section at Church and Carlton that had re-opened as a giant Loblaws grocery store a year earlier. But I had to admit I was curious. There was a charity game featuring locked-out NHLers, and we decided it would be a nice idea for me to shoot a game there again and bring things full circle.

At first, I was really pumped. The crowd outside was big, there was a buzz in the air and it was a winter night. It was almost like *Hockey Night in Canada*. Almost.

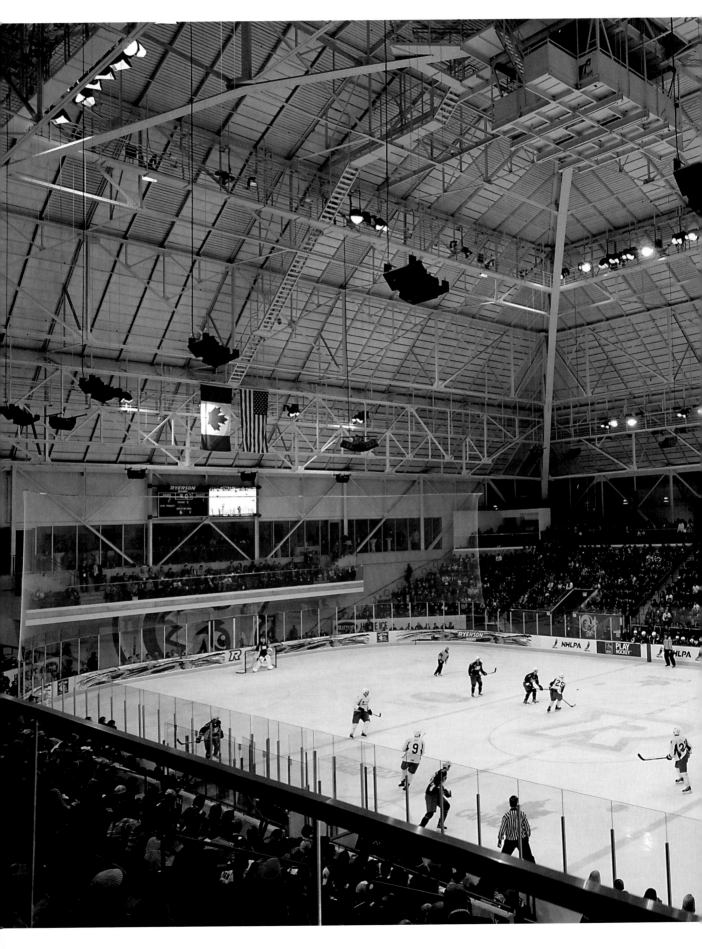

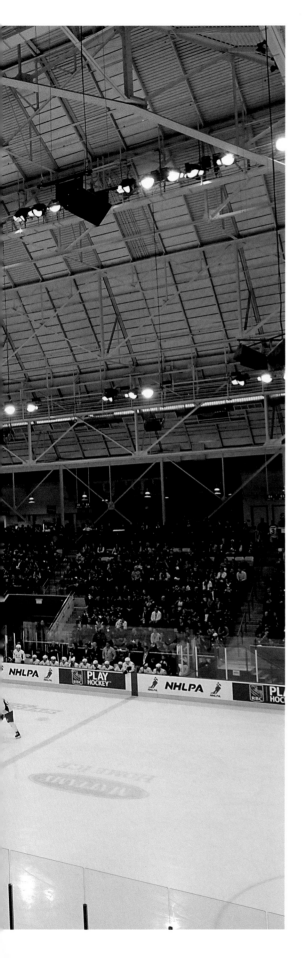

The closer I got, I could see it wasn't the same. The 3,000-seat rink is up where there would have been the green and greys. They did a great job renovating, but I expected more of a Leafs presence in terms of pictures and such. If you didn't look up and see the familiar roof, you wouldn't have known it was the Gardens.

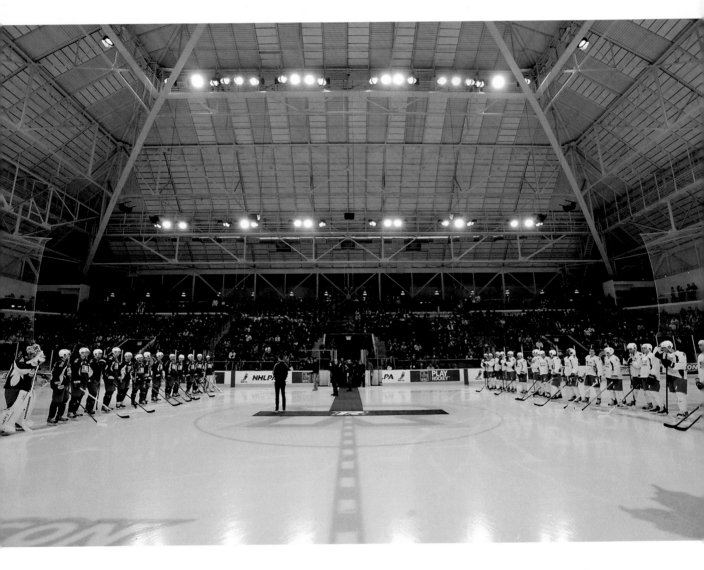

Any university kid would like the atmosphere in there. I stood in the same spot I used to—three storeys higher, of course—and shot a period or two, trying to get into the spirit.

But there wasn't enough blue and white in it for me.

AT THE GARDENS Hockey Stats

· ·

Most goals by a Leafs player
Darryl Sittler 235
Dave Keon 226
Ron Ellis 186
Frank Mahovlich 180
Rick Vaive 174
George Armstrong 173
Wendel Clark 151
Bob Pulford 148
Teeder Kennedy 138
Ron Stewart 123

Most goals by opposing team players
Gordie Howe 93
Alex Delvecchio 62
Johnny Bucyk 57
Henri Richard 53
Jean Béliveau 51
Bobby Hull 49
Ted Lindsay 47
Maurice Richard 46
Dean Prentice 45
Dickie Moore 44

Most points by a Leafs player
Darryl Sittler 524
Dave Keon 521
George Armstrong 412
Börje Salming 398
Frank Mahovlich 376
Ron Ellis 360
Bob Pulford 342
Norm Ullman 336
Teeder Kennedy 323
Rick Vaive 307

Most points by opposing players
Gordie Howe 126
Johnny Bucyk 87
Alex Delvecchio 80
Bobby Hull 80
Wayne Gretzky 77
Jean Béliveau 75
Maurice Richard 74
Henri Richard 73
Steve Yzerman 73
Denis Savard 66

MILESTONES

. .

First game: November 12, 1931. Chicago 2, Toronto 1.

Attendance: 13,233.

First goal (same date): Harold "Mush" March (Chicago) vs. Lorne Chabot.

First Toronto goal (same date): Charlie Conacher vs. Charlie Gardiner.

Last game: February 13, 1999. Chicago 6, Toronto 2.

Last goal (same date): Bob Probert (Chicago) vs. Curtis Joseph.

Last Toronto goal (same date): Derek King vs. Jocelyn Thibault.

ACKNOWLEDGEMENTS

There some people I would like to thank for giving me the opportunity for this book and for my chance to be the Toronto Maple Leaf Team photographer.

Top of my list is my dad, Charles Abel. He spent many hours driving me to hockey and watching me play. We had to delay one of our many fishing trips so I could attend my hockey banquet where I received an MVP award. I had no idea that I would be receiving it until I got there, but he knew. My dad never questioned me when I had to leave the office to go to the Gardens, whether to deliver prints or to shoot an event such as a press conference or team photo. He always backed me on pursuing my dream of being a sports photographer. Whether it was film, developing services or camera equipment, it was all made available to me without hesitation. For that, I thank him. He also likes to brag about his son the Leafs photographer.

There were many nights that I was not home until very late, but I tried my best not to miss one of the kids' events and to be there for them. Dave and Katie have always backed their dad and they, too, brag a little about what he does for a living. Thanks, guys! I still have a chuckle that I'm the only one in the family that has not won an award. Katie won a prize in high school for photography and Dave won a National Newspaper Award.

There are many people at Maple Leaf Gardens and the Air Canada Centre who have made my job enjoyable and much easier. Bill Cluff gave me the opportunity to start shooting Leafs games, Bob Stellick and then Pat Park, the directors of media relations, and Terri Giberson at the Toronto Rock. Bob, Pat and Terri have always been great people to deal with and have always been more than helpful in giving me access to events and special projects. It is always rewarding when they ask me for help assigning other photographers and for my opinions on pictures.

Lance Hornby wrote an article a few years back about my long career with the Leafs. Must have been a slow news day at the *Toronto Sun*! I'd had a few stories written about being the team photographer, but Lance and I hit it off right from the beginning. We both have a strange sense of humour, which is needed when trying to put something like this together.

When I approached him about helping me on this project, he was more than willing. I'm not a writer, and to put my stories into book form I did need someone to help me express myself. Lance was somehow able to capture the stories I wanted to tell, and I really thank him for that.

Jack David and Michael Holmes at ECW Press listened to our pitch and, right from the start, thought it was a great idea. ECW gave Lance and me the opportunity to put *Welcome to Maple Leaf Gardens* together the way we envisioned.

The Ontario Arts Council also helped us out with a grant. It takes a lot of time to gather the photos and put together the stories and their assistance is appreciated.

Graig Abel
June 2013